MISSISSIPPI WITNESS

MISSISSIPPI WITNESS

THE PHOTOGRAPHS OF
FLORENCE MARS

JAMES T. CAMPBELL AND ELAINE OWENS

UNIVERSITY PRESS OF MISSISSIPPI / JACKSON

The University Press of Mississippi is the scholarly publishing agency of
the Mississippi Institutions of Higher Learning: Alcorn State University,
Delta State University, Jackson State University, Mississippi State University,
Mississippi University for Women, Mississippi Valley State University,
University of Mississippi, and University of Southern Mississippi.

www.upress.state.ms.us

The University Press of Mississippi is a
member of the Association of University Presses.

All royalties from the sale of this book will be
paid to the Mississippi Civil Rights Museum.

First printing 2019

∞

Library of Congress Cataloging-in-Publication Data

Names: Campbell, James T., author of introduction. | Owens, Elaine, 1950–
compiler.
Title: Mississippi witness: the photographs of Florence Mars / James T.
Campbell and Elaine Owens.
Description: Jackson: University Press of Mississippi, [2019] | Includes
bibliographical references and index. |
Identifiers: LCCN 2018025093 (print) | LCCN 2018029214 (ebook) | ISBN
9781496820914 (epub single) | ISBN 9781496820921 (epub institutional) |
ISBN 9781496820938 (pdf single) | ISBN 9781496820945 (pdf institutional)
| ISBN 9781496820907 (cloth)
Subjects: LCSH: Mars, Florence, 1923–2006—Pictorial works. | Documentary
photography—Mississippi—Philadelphia. | Philadelphia (Miss.)—Race
relations. | Philadelphia (Miss.)—Social life and customs—20th century.
| Mississippi—History—20th century. | LCGFT: Photobooks. | Illustrated
works.
Classification: LCC E185.93.M6 (ebook) | LCC E185.93.M6 M578 2019 (print) |
DDC 305.8009762/6850222—dc23
LC record available at https://lccn.loc.gov/2018025093

British Library Cataloging-in-Publication Data available

To two Mississippians:
Stanley Dearman and Hollis Watkins

CONTENTS

ACKNOWLEDGMENTS

To produce a book is to accumulate debts that one can never adequately repay.

Our first and greatest debt is to the people who made the images, not only to Florence Mars but also to the individuals who appear within the frame. We have been able to identify only some of the latter. What passed between them and Mars is lost to us. But together they created works of surpassing beauty and power, shimmers of light in a dark time.

Many people shared stories of Mars and of the extraordinary historical events in which she and they were swept up. Heartfelt thanks to Betty Pearson (Mars's onetime college roommate and lifelong friend), Stanley Dearman, Carolyn Dearman, Dick Molpus, Dawn Lea Mars Chalmers, Jeremy Chalmers, Jewel Rush McDonald, Cleo McDonald, Evelyn Cole Calloway, Fent DeWeese, Rita Bender, Bill Bender, Carolyn Goodman, David Goodman, Ben Chaney, Julia Chaney Moss, Dave Dennis, Charlie Cobb, and the Reverend Clinton Collier. Sadly, many on the list did not live to see the book's completion.

Several friends and colleagues read drafts of the book's introduction, offering helpful comments and corrections. Thank you Stanley Dearman, Joe Crespino, Andrea van Niekerk, Kim Beil, Bruce Schulman, and Annette Counts. Conversations with Laura Wexler helped to illuminate the complex ethical issues inherent in documentary photography, particularly with photographs taken in contexts of profound structural inequality. Sarah Wishingrad and Robbie Zimbroff provided invaluable research assistance. Indeed, it was Robbie who first glimpsed the possibility of a book. Thank you.

Staff at the Mississippi Department of Archives and History, where Mars's photographs are housed, were unfailingly gracious and helpful. Special thanks to director Katie Blount, Archives and Records Services director David Pilcher, and scanning technician Judy Hocking.

Working with the University Press of Mississippi has been a delight. Craig Gill supported the project at every turn. Todd Lape designed the book. Emily Bandy kept the world from spinning apart.

Our families make all things possible. Thank you Pete, Michael, Stephen, Laurie, Andrea, Thomas, Daniel, and Leah.

Born on opposite sides of Mississippi's Jim Crow divide, Stanley Dearman and Hollis Watkins saw the violent terror of 1964 close at hand. In their different ways, both dedicated their lives to making their native state a more just and decent place. We dedicate the book to them.

MISSISSIPPI WITNESS

INTRODUCTION

Certain Things Are Taken to Be Self-Evident

James T. Campbell

To understand someone, Florence Mars used to say, you needed to know "the background." You had to go back to the beginning, to understand people's origins, their families, the "sum total" of their history. The photographs in this book reflect Mars's attempt to understand her own background, to come to terms with a world that she loved and loathed, a world awash in beauty and rife with violence and cruelty.

The photographs were taken in Mississippi, most in the vicinity of Philadelphia, a small country town in the red clay hills of Neshoba County. Mars herself was a fourth-generation Neshoban, descended from families who first entered the area following the 1830 Treaty of Dancing Rabbit Creek, which opened 11 million acres of Choctaw land to white settlement. With a few exceptions, the photos were taken between 1954 and 1964, against the backdrop of a burgeoning black freedom movement and a murderous white reaction. "I knew the old relationship between white and Negro was over," she later recalled. "Because I knew the street scenes of Philadelphia would soon begin to change, I bought a camera and enlarger, built a darkroom, and began to snap thousands of pictures."[1]

What Mars could not have anticipated was the way that the forces of freedom and reaction would converge on her hometown. On June 21, 1964, three civil rights workers—James Chaney, Michael Schwerner, and Andrew Goodman—were murdered on a country road outside Philadelphia. The young men had come to Neshoba County to investigate the burning of Mount Zion Methodist Church, a small, wood-frame church in Longdale, a community of independent black landowners ten miles east of Philadelphia. Schwerner, a white New Yorker, and Chaney, a black Mississippian, were veteran activists working under the auspices of the Council of Federated Organizations (COFO), an umbrella civil rights group with an office in nearby Meridian. Goodman, also a white New Yorker, had arrived in Mississippi only the day before, the first of some

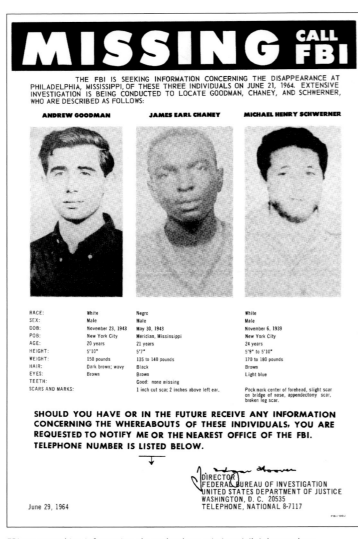

MISSING CALL FBI

THE FBI IS SEEKING INFORMATION CONCERNING THE DISAPPEARANCE AT PHILADELPHIA, MISSISSIPPI, OF THESE THREE INDIVIDUALS ON JUNE 21, 1964. EXTENSIVE INVESTIGATION IS BEING CONDUCTED TO LOCATE GOODMAN, CHANEY, AND SCHWERNER, WHO ARE DESCRIBED AS FOLLOWS:

ANDREW GOODMAN **JAMES EARL CHANEY** **MICHAEL HENRY SCHWERNER**

RACE:	White	Negro	White
SEX:	Male	Male	Male
DOB:	November 23, 1943	May 30, 1943	November 6, 1939
POB:	New York City	Meridian, Mississippi	New York City
AGE:	20 years	21 years	24 years
HEIGHT:	5'10"	5'7"	5'9" to 5'10"
WEIGHT:	150 pounds	135 to 140 pounds	170 to 180 pounds
HAIR:	Dark brown; wavy	Black	Brown
EYES:	Brown	Brown	Light blue
TEETH:		Good: none missing	
SCARS AND MARKS:		1 inch cut scar 2 inches above left ear.	Pock mark center of forehead, slight scar on bridge of nose, appendectomy scar, broken leg scar.

SHOULD YOU HAVE OR IN THE FUTURE RECEIVE ANY INFORMATION CONCERNING THE WHEREABOUTS OF THESE INDIVIDUALS, YOU ARE REQUESTED TO NOTIFY ME OR THE NEAREST OFFICE OF THE FBI. TELEPHONE NUMBER IS LISTED BELOW.

DIRECTOR
FEDERAL BUREAU OF INVESTIGATION
UNITED STATES DEPARTMENT OF JUSTICE
WASHINGTON, D. C. 20535
TELEPHONE, NATIONAL 8-7117

June 29, 1964

FBI poster seeking information about the three missing civil rights workers, June 1964.

eight hundred student volunteers brought into the state by COFO as part of its 1964 "Freedom Summer" project. Arrested on trumped-up speeding charges, the three were held for seven hours in Philadelphia's tiny jail while members of the Neshoba and Lauderdale County chapters of the Ku Klux Klan set in motion a preconceived "elimination" plan. Released late in the evening, they were intercepted on their way back to Meridian, driven to a remote crossroads, shot, and buried in an earthen dam, from which their bodies were recovered after a forty-four-day search.[2]

Such is the notoriety of the case that it takes some effort to remember that Chaney, Schwerner, and Goodman were not the only civil rights workers murdered during Jim Crow's violent death throes. In Mississippi alone, the roster includes George Lee, Lamar Smith, Herbert Lee, Medgar Evers, Louis Allen, Vernon Dahmer, and Wharlest Jackson, to name only some. Countless other people were beaten and terrorized. One of the objects of the 1964 Freedom Summer project was to dramatize the violence that organizers routinely faced in the state. The idea, simply put, was that if the people being assaulted and killed were white students from prominent northern universities rather than black Mississippians, then the federal government might finally be roused to action. "There was a tremendous amount of violence in the state that was being ignored," one COFO field-worker later explained. "You had to bring the country's attention to the state, and the obvious way to do that is to bring the country's children down there."[3]

Events quickly confirmed the calculus. The disappearance of Chaney, Schwerner, and Goodman transfixed the nation. The national press corps decamped for Neshoba County, including several reporters from the *New York Times,* whose executive editor, Turner Catledge, was himself a native of Philadelphia. Walter Cronkite reported nightly on developments in "Bloody Neshoba." President Lyndon Johnson met with the families of the missing men and dispatched two hundred FBI agents to the state to aid in the investigation (over the objections of FBI director J. Edgar Hoover, who publicly insisted that the Bureau would not play "wet nurse" to racial agitators). Sailors from the naval air station at Meridian were deployed to help search for the bodies.

Clearly, the Philadelphia murders garnered national attention because two of the victims were white. But they also owe their notoriety to the conduct of local townsfolk, who contrived to live down to every northern stereotype of southern recalcitrance and bigotry. Egged on by state and local leaders, white Neshobans loudly dismissed the disappearance as a "hoax," perpetrated by the three men themselves in order to discredit Mississippi and pave the way for a federal "invasion" of the state. Journalists covering the case were assaulted and shot at. A cameraman for NBC had his car rammed in plain view of a local policeman, who then ticketed him for reckless driving. Locals lined bridges to heckle searchers dragging streams and swamps below. Investigators met stony silence. "Neshoba County did not need a Klan," the FBI's lead inspector in the case later remarked, since the residents themselves were "the most conspiratorial group" he had ever encountered. "They were just naturals."[4]

Even after the FBI broke the case, arresting nineteen men on federal conspiracy charges, local whites remained defiant. Many claimed that the victims had been murdered by their own civil rights colleagues to win sympathy for the movement. According to one ubiquitous rumor, the dirt on the recovered bodies did not match the dirt where they were buried, confirming that they had been killed elsewhere and planted in Neshoba County. Others acknowledged what had happened but insisted that the three young men had been "looking for trouble" and "got what they deserved." With the filing of federal charges—the state of Mississippi declined to prosecute the case—the entire Neshoba County bar enlisted in the defense team, which was supported by a community fund-raising campaign, complete with donation jars in local banks and businesses.[5]

As the case dragged on through dismissals and reindictments—it would ultimately take a decision by the U.S. Supreme Court for the prosecution to proceed—the accused men swaggered around town. Deputy Sheriff Cecil Price, who would eventually serve four-and-a-half years in federal prison for his role in the killings, cited his experiences in the summer of 1964 as a job qualification in his 1967 campaign for sheriff. "I think my actions in the past prove that I want our way of life upheld whenever it is attacked by outsiders who have no real interest here except to stir up trouble," he declared in announcing his candidacy. Price ran a strong third in the dozen-candidate race, which was won by another of the accused, Hop Barnett. (Barnett's prosecution ended in a hung jury, enabling him to serve out his term as sheriff.)[6]

In this atmosphere of furious conformity, only a tiny handful among white townspeople spoke out, braving social ostracism and threats of violence to denounce the murders and decry the climate of fear and intimidation that had overtaken their community. Few did so more openly and courageously than Florence Mars. She confronted local leaders, vainly urging them to speak out. She cooperated with FBI agents working the case and agreed to testify to a federal grand jury investigating the brutal treatment of black citizens by local authorities. She spearheaded a "Philadelphia-to-Philadelphia" project, a youth exchange with the town's Pennsylvania namesake, which was reeling from its own racial upheavals. She launched a local fund-raising campaign to rebuild Mount Zion Church, in direct opposition to the "Defense Fund" being raised on behalf of the killers. Offered a choice between "church builders and church burners," she hoped, the "decent folk" of Philadelphia might finally stand up and condemn the murders.[7]

In her book, *Witness in Philadelphia,* one of the classic memoirs of the civil rights era, Mars recounted the reactions her conduct provoked—the

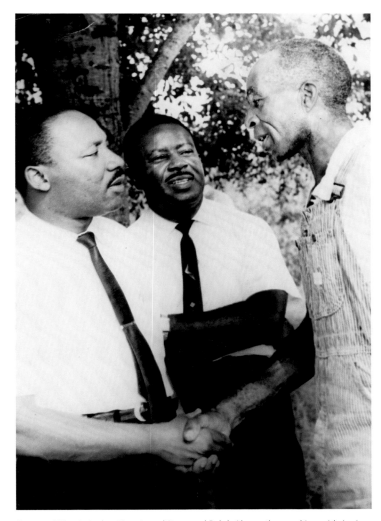

Reverend Martin Luther King Jr. and Reverend Ralph Abernathy speaking with Junior Roosevelt "Bud" Cole, one of the congregants beaten by Klansmen the night they burned Mount Zion Methodist Church, July 24, 1964. Photo by Stanley Dearman.

police surveillance, the obscene phone calls and death threats, the shunning by neighbors. Rumors swirled that she was on the payroll of COFO, the FBI, or both. A Klan-organized boycott forced her to sell her business. She became such a thorn in the side of Sheriff Lawrence Rainey (another of the accused) that he tossed her in the drunk tank, an act that scandalized some townspeople more than the murders themselves. The fund-raising campaign for Mount Zion collapsed after prospective donors demanded assurance that the new building would never be

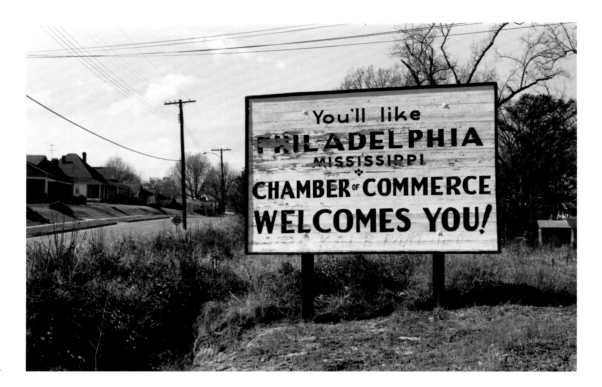

Philadelphia welcome sign, no date.

used for civil rights–related activities, a condition that church members refused. Perhaps most painful, Mars was forced to resign from her work at Philadelphia's First Methodist Church, where she taught a women's Bible class and convened the high school youth group, after protests from congregants who feared contamination by her dangerous beliefs.

❖ ❖ ❖

Florence Mars was obviously a singular woman, but her experience raises universal questions, the questions humans always ask in the aftermath of atrocity. How do we explain the events of 1964, not only the murders themselves but also a community's retreat into furious denial? How do ordinary people become complicit in grave injustice? And how, in such fevered circumstances, do a few people find the courage to resist, to recognize evil and call it by its name? Mars herself often pondered these questions. "Lots of us have discussed that," she told one interviewer. "The people who grew up here, or grew up with certain pressures, or any group of people—why is it that some seem to be able to get outside and see?"[8]

How do some people "get outside and see"? In Mars's case, part of the answer surely lies with her family. Though its Neshoba roots ran deep, the Mars family was always a contrarian lot, conscious of its difference from "the great unwashed crowd." "We were the Sartorises of Neshoba County," Mars explained, indulging the inevitable Faulkner reference. Family members went to college. They "read books" and had the "habit of conversation." They argued over dinner and were never afraid to ask questions, even if it meant challenging small-town verities. In *Witness in Philadelphia,* Mars recounted a childhood trip to the 1934 World's Fair in Chicago, where she saw dinosaur bones—bones whose age belied her Sunday School teacher's claim that the earth was only four thousand years old. Returning to Philadelphia, she immediately challenged him. "It's just better not to go into things like that," he replied. Even as a child she found that answer silly.[9]

Such a household bred its share of eccentrics and more than its share of tragedy. Adam Mars, Florence's father, was a gentle, soft-spoken man, with a beautiful tenor voice and an addiction to morphine, acquired in the 1920s, when the drug was touted as a hangover cure. He attended the University of Mississippi (where he counted among his friends a

young William Faulkner) and dreamed of a career in music, but he was pressured by his father into studying law, which he practiced desultorily until his death from alcohol poisoning, a few days after his daughter's eleventh birthday. Adam's younger brother, William Fenton Mars, was also an alcoholic and morphine addict, as well as a genius with a near photographic memory. William "never worked a day in his life," but he was a familiar figure in Philadelphia, strolling the streets reciting Shake-speare, the Latin Mass, and the *Rubaiyat of Omar Khayyam* from mem-ory. Another brother, James, committed suicide shortly after returning from service in World War II. Florence's mother, Emily Geneva Johnson, known as Neva, was more conventional, at least by comparison, but Neva's older sister, Ellen, was anything but. Red-haired and flamboy-ant—"a dead ringer for Ethel Barrymore," a friend remembered, "and just as histrionic"—she bobbed her hair, smoked, listened to jazz records, and moved to New Orleans, where she met and married a Swedish ship's captain. Returning to Philadelphia in the early 1960s, Ellen would join her niece as an outspoken opponent of the Klan.[10]

The paterfamilias of the Mars clan—and the formative influence on young Florence—was her grandfather, W. H. "Doc" Mars, a plump, suspendered man who was also the county's largest landowner. Born two years after the end of the Civil War, he earned a medical degree at Vanderbilt but practiced only briefly, devoting his energies instead to Mars Brothers, a country store that he opened with his younger brother in 1891. Relocated to Philadelphia's courthouse square in 1905, the year the railroad came to town, Mars Brothers sold everything from shoes to shovels, but its main business was "furnishing" farmers—supplying struggling landowners and tenants with rations, cotton seed, mules for ploughing, and whatever else they needed to stay alive and pull a crop from the ground, all at 8 percent per annum. When the inevitable defaults happened, the good doctor was not shy to foreclose, a practice that enabled him to accumulate more than seventeen thousand acres of Neshoba County land.

According to Florence herself, Doc Mars had insisted on presiding over the birth of his first grandchild and then botched the delivery, leav-ing her with a host of physical ailments, including a foreshortened leg and a lifelong limp. But she bore him no grudge; on the contrary, she adored her "Poppaw." She spent endless days with him growing up, tra-versing the county's clay and corduroy roads in his large sedan to visit tenants and collect debts. Always inquisitive, she barraged him with questions but rarely got "straight answers," receiving instead long dis-quisitions about local history and the origins of different families. As a

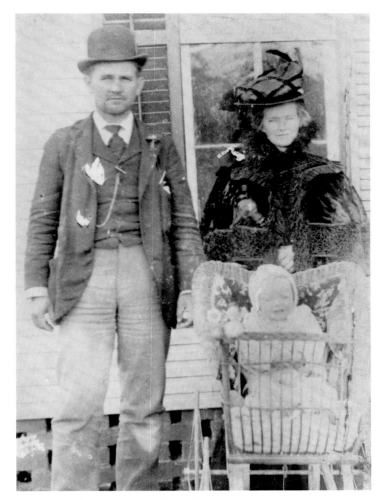

Mars's paternal grandparents, W. H. "Doc" Mars and Florence Lattimer Mars, with Adam, her father. Family photo, ca. 1900.

child, she found this penchant for roundabout answers frustrating, but, in time, she realized that the context "*was* the answer." "I grew to under-stand what Poppaw must have thought, that an answer can't be under-stood without knowing the background. This habit can be tiresome, especially when you're in a hurry, but neither one of us was."[11]

Though they rarely discussed racial questions directly, Mars clearly inherited some of her heterodox views from her grandfather. It was he who first called her attention to the large number of fair-skinned black families in the county, many of whom bore the same last names as prominent white families—an "astounding revelation for a child." (Mars

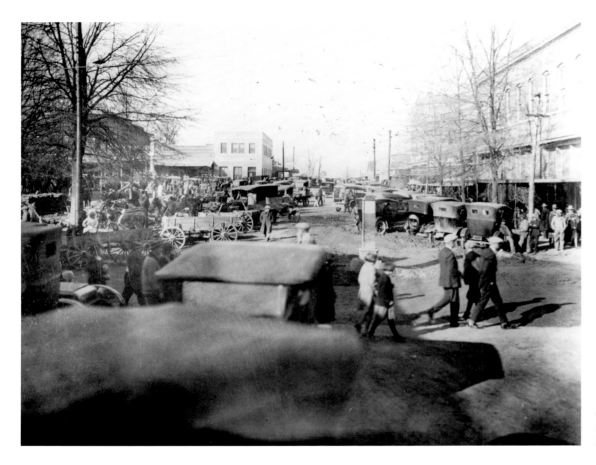

Courthouse square, Philadelphia, MS, ca 1920. Copy print by Frank Noone. Courtesy of Randy Noone.

would later learn that her maternal great grandfather had sired a black family, leaving her with an assortment of black cousins.) He showed her a tree where a black man had been lynched and joined her in supporting Harry Truman in the election of 1948, even as voters in Neshoba County and across the state flocked to the banner of Strom Thurmond's Dixiecrats. "What is this business with the Negro?" Florence once asked him, after witnessing some racist affront. "I'll always remember the way he answered," she later wrote. "He leaned forward, placed both elbows on his knees with his hands clasped together and said, 'They've been treated mighty bad.'"[12]

Many of Poppaw's tenants were black, and he and Florence would periodically visit them, lingering to swap stories or share a meal, occasionally attending service in one of the small black churches dotting the countryside. A favorite stop was the old family homestead in the Cushtusa community, now occupied by a black family whose roots in the area traced back to slavery days. As a child, Mars marveled at the "gracious ways" of the black people she met, at the "good humor and patience" they retained in the face of cruelty and privation. Looking back years later, she would realize how patronizing her attitude had been, how the "smiling, carefree" face that black people presented to the world was often a façade, part of a painfully learned survival strategy. "It became clear to me that their demeanor on down to the smallest child must have been taught," she wrote. "If a member of that race showed a different attitude and demeanor, they were 'uppity' and in some circles it might cost them their life." Nonetheless, she counted herself blessed to have had this early, positive glimpse into the black world. "I knew I was fortunate to have been raised in such close proximity to Negroes and wondered why others did not feel kindly" toward them.[13]

If Mars inherited a certain paternalistic fondness for black people from her grandfather, she inherited precisely the opposite attitude

toward poor whites. While conceding that some of his white tenants were hard-working, decent folks, Poppaw was contemptuous of most, dismissing them as "peckerwoods," "rednecks," and "poor white trash"— "the sorriest tenants in the county." His feelings were clearly reciprocated by the tenants themselves, who greeted their landlord without warmth or fondness. The generosity and open-heartedness that Mars sensed during visits with black tenants were completely absent in encounters with whites, who struck her as crabbed and querulous, always ready to blame someone else for their failings. In contrast to her attitude toward black people, which matured and deepened over the years, her feelings about poor whites seem never really to have changed. Though she never said so directly, it seems likely that Mars's willingness to stand up to the Klan decades later flowed, at least in part, from class prejudice, her enduring disdain for the kind of people she took Klansmen to be.[14]

◆ ◆ ◆

The seeds planted in Mars's youth would germinate in college. She spent a year at Millsaps, a liberal arts college in Jackson, where she wrote a column on jazz for the student newspaper and made a lifelong friend in Betty Bobo, daughter of a wealthy Delta planter, who had also come to question the protocols of white supremacy. She took a course in sociology from Vernon Wharton, author of *The Negro in Mississippi, 1865–1890,* a path-breaking account of the Reconstruction era in the state and of the violent white supremacist campaign that ended it. Years later, Mars could still recall her amazement seeing Wharton shake hands with a black woman he had invited to speak at the college. "This was the first time I had ever heard an educated member of the Negro race afforded the courtesy of being addressed as 'Mrs.,'" she wrote, adding that, in Neshoba County, the "best you could do without ostracization would be to address the ancient ones as 'Auntie' or 'Uncle.'"[15]

In 1941, Mars and Bobo transferred to the University of Mississippi, where their racial educations continued. Shortly after their arrival, black washerwomen on campus went on strike, seeking a few pennies an hour increase as well as the introduction of fans in the sweltering university laundry. Mars and Bobo became involved in the strike, although they had different recollections of precisely how. In Mars's telling, they were concerned that the women, several of whom they had come to know personally, would be sacked. Bobo, in contrast, maintained that it was they who first suggested the idea of a strike to the women. Whatever the circumstances, they went to see the white manager of the laundry. He

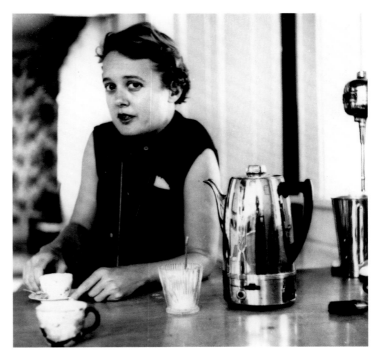

Florence Mars, early 1950s.

received them courteously, but, when they broached the subject of the strike, "his face went red with anger." "What Northern Communist newspaper do you represent?" he demanded. It was an apt preview of white Mississippians' response to the civil rights movement a generation later.[16]

Mars traveled widely in the years after college, further broadening her horizons. Prevented from enlisting in the armed forces by her physical disability, she spent the war years in Atlanta working for Delta Airlines, arranging transport for military personnel. After the war, she traveled to New York City, where she frequented jazz clubs such as the Royal Roost, listening to Thelonious Monk, Billy Eckstine, and other progenitors of bebop. She attended a Billie Holiday concert and bought a recording of "Strange Fruit," Holiday's searing indictment of southern lynching. The recording led her, in turn, to Lillian Smith's novel of the same name, as well as to *Killers of the Dream,* Smith's semiautobiographical exploration of the psychic and spiritual damage that segregation had wrought in southern whites. A small-town woman who defied the racial and sexual norms of her natal region, Smith became an important model for Mars, though they appear never to have met. Years later, struggling to write *Witness in Philadelphia,* Mars would keep on her desk a passage from

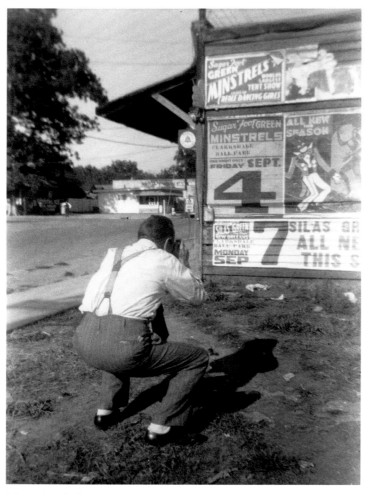

Ralston Crawford outside Clarksdale, 1959.

Neshoba County on the map but a universe away culturally. She entered psychotherapy in New Orleans, which she continued, off and on, for a decade. She frequented local jazz clubs and found her way into the white bohemian community clustered around *The Outsider,* a literary journal featuring the work of Beat writers such as Jack Kerouac and Allen Ginsberg. Seeking a creative outlet of her own, she took up painting, studying under Fred Conway, a noted American muralist and teacher of art. Mars would ultimately find her outlet not in painting but in photography, a medium she had first discovered as a teenager at summer camp, but she continued to hew to Conway's vision of art as a personal discipline, a means of "ordering the imaginative being." She often quoted a passage from one of his letters: "The problem as I see it is to live each day doing a thing which exacts you, and to keep that up, a process of learning, of living."[18]

Mars would find another important friend and mentor in Ralston Crawford, an artist and leader of the "Independents," a movement of American modernists that had arisen from the artistic and political upheavals of the 1930s. Though best known for his stark, geometric paintings of industrial landscapes, Crawford was also an accomplished photographer, and he encouraged Mars's dawning interest in the medium. The two friends would spend countless hours together in the late 1950s and early '60s, photographing New Orleans street performers and jazz musicians, creating a priceless record of a musical world that was not yet widely appreciated beyond the city's borders. They also undertook periodic photographic excursions to Mississippi, including one memorable expedition to find and photograph some of the last traveling minstrel troupes in the United States.[19]

In *Witness in Philadelphia,* Mars would portray her turn to photography as a response to the political turmoil engulfing Mississippi in the 1950s, but there was clearly more to it than that. Her decision to create a photographic record of her world was part of a long personal journey, a decades-long quest to make sense of the place in which she had grown up and of her own conflicted relationship to it. How do some people learn to see? The answer, in the case of Florence Mars, was through the lens of a camera.

Smith's preface to *Killers of the Dream*: "I wrote it because I had to find out what life in a segregated culture had done to me, one person. I had to put down on paper those experiences so that I could see their meaning for me. I was in dialogue with myself as I wrote, with my hometown and childhood and history as well as the future, and the past."[17]

Poppaw died in 1950, leaving Mars as his primary heir. She used some of the legacy to start a farm, converting played out cotton land into pasturage for a herd of purebred Herefords. She also opened a stockyard, where local farmers came weekly to buy and sell cattle. The businesses ensured that she returned frequently to Philadelphia, but she spent most of the 1950s in New Orleans, a city only two hundred miles from

◆ ◆ ◆

In 1954, Mars purchased a Graflex 22, an inexpensive knob-wound camera with top viewfinder, and began to take pictures. She started close to home, photographing Philadelphia street scenes she had known

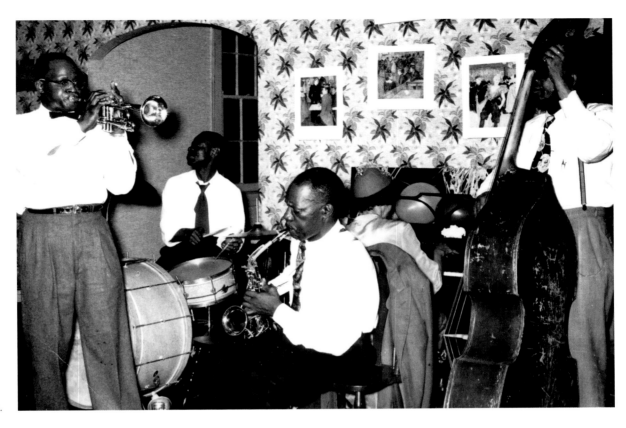

New Orleans jazz scene, 1962.

since childhood: boys clambering on the town's Confederate memorial; a bootlegger's paraphernalia displayed on the courthouse lawn after a raid; shoppers, black, white, and Choctaw, gliding past one another on the town square, oblivious to their kinship. After a day of shooting, she retreated to the makeshift darkroom that she had built in an upstairs hallway of her old childhood home, the ground floor of which was now occupied by her Uncle William. With a separate entrance to come and go, she often worked late into the night, accompanied only by the click of the enlarger and William's sleepless mutterings. When she found an image she liked, she printed it over and over, burning and dodging, determined to bring out the planes of a face or the strength in a pair of hands. Aside from one or two photos that appeared in *The Outsider,* she made no attempt to exhibit or publish the images. They were her private devotion, her way of exacting herself.

Many of Mars's early photos were taken at a local fish fry. As in other Mississippi market towns, farmers came to Philadelphia on Saturdays to buy supplies and socialize. Among them was a black woman named Roxie Kirkland, a long-time acquaintance, who sold fish sandwiches with ketchup in a vacant lot off the square. As lunchtime rolled around, black folk found their way to the spot, eating and gossiping in the narrow shade of a cardboard tarp. Mars began taking photos there, returning each week to share prints and make more pictures. She continued for more than a year, following the group from one vacant lot to another until it was finally shut down entirely. Most of the images were portraits: Kirkland bending over the battered iron wash pot she used to fry the fish; a solemn young girl in a white dress standing amidst rusting farm implements; a local schoolteacher sitting on an orange crate, clutching half-a-dozen copies of the *Chicago Defender,* a black newspaper that had circulated, often surreptitiously, in Mississippi since the 1910s. The headline in the photo promises news of the continuing upheaval in Trumbull Park, touched off after an official in the Chicago Housing Authority unwittingly admitted a light-skinned black couple to a previously all-white housing project. The image conveys multiple messages: that black Mississippians were never the political innocents that whites imagined

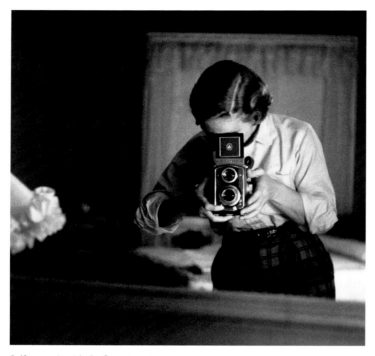

Self-portrait with Graflex 22, ca. 1955.

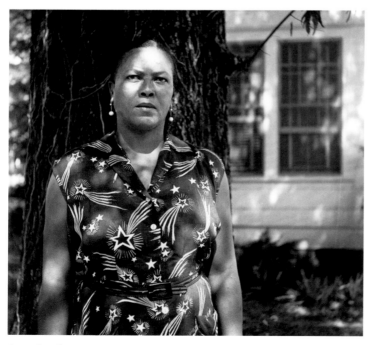

Gertrude Williams, 1955 or 1956.

them to be; that violent opposition to integration was not a southern monopoly; that "race" is not so simple a thing.[20]

As her confidence grew, Mars began to venture more widely, exploring the backroads she had once traversed with her Poppaw, her camera on the seat beside her. She was sometimes accompanied on her travels by Gertrude Williams, a black woman who worked in her kitchen. A former bootlegger, Williams was illiterate, but she was rich in "mother wit" and became an important interlocutor and confidante. The relationship gave Mars access to arenas of black experience that few white photographers ever saw: a preacher exhorting his congregation; a church picnic; neighbors gathering together in the fall to make cane syrup and butcher hogs. Williams also provided insight into the realities of black life in rural Mississippi, the hard necessity lurking beneath the genial surface. In one early conversation, Mars asked her when she had first realized that "her life would be different" because she was black. Williams recalled an episode when she was still just a "little, bitty girl," holding her aunt's hand outside a burning cabin and listening to the screams of those trapped within, while white men with shotguns hovered nearby to ensure that no one escaped or offered assistance. "In my growing-up days I had never given a thought to how much more the little black child had to know just to stay alive," Mars later wrote. "Gertrude had a way of putting flesh on the bones."[21]

Given their subject matter and locale, Mars's photos inevitably invite comparison with the work of the photographers of the New Deal–era Farm Security Administration. It is no exaggeration to say that the FSA photographers—Walker Evans, Dorothea Lange, Ben Shahn, and others—elevated documentary photography into one of the signature arts of twentieth-century America, while also creating an enduring visual vocabulary of the rural South. Mars was certainly familiar with the language. Indeed, some of her photos seem intended as studies on the work of the FSA photographers: enamel signs on battered storefronts; weathered shacks of sharecroppers; tenant farmers framed amidst their meager possessions. Like her predecessors, Mars could be unsparing in her portrayal of poverty and injustice, without reducing the people in the frame to figures of pathos. On the contrary, her subjects come across as vital, resilient, even proud. Dorothea Lange's ruminations on photographing Depression-era migrant workers speak equally to Mars's accomplishment: "I had to get the camera to register the things about these people that were more important than how poor they were—their pride, their strength, their spirit."[22]

An even better reference point for Mars's photos is the work of fellow Mississippian Eudora Welty. Though renowned as a writer, Welty began

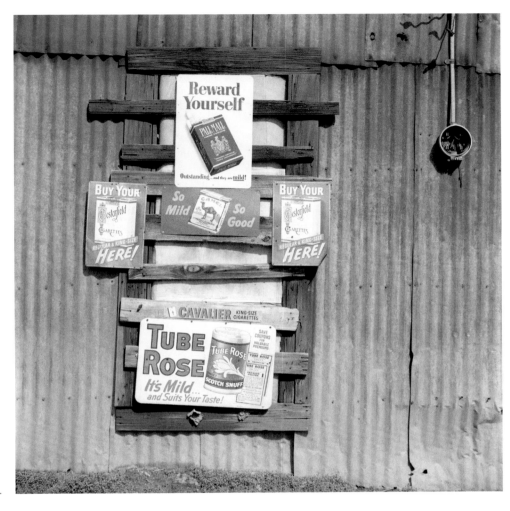

Enamel signs, no date.

her career as a photographer, taking "snapshots" while working as a publicity agent for the Works Progress Administration, another New Deal–era federal agency. All but forgotten, the photos were rediscovered late in Welty's life and published in a definitive edition by the University Press of Mississippi in 1989, earning her belated recognition as one of the South's most distinguished photographers. It is unlikely that Mars had seen any of these images when she was taking her own photographs, but she certainly knew and admired Welty's writing and recognized her as a kindred spirit. The similarities in their circumstances and sensibilities are obvious. Single white women, they lived at once inside and outside the confines of a conservative, racist, patriarchal society. Solitary by nature, both understood the human yearning for connection. Acutely

observant, both saw the wonder in ordinary life, the aching beauty that survived amidst the ugliness.[23]

Similarities in sensibility produced striking similarities in Mars's and Welty's photos. Both produced images of graveyards and gas stations, of black women in white dresses and black men slaughtering hogs. In a few cases, the resemblances are uncanny: a photograph of a black woman crossing the pavement on Philadelphia's courthouse square echoes an image Welty captured in Utica twenty years before. Yet for all the similarities, there are also important differences between the two women's work, reflecting not only differences of technique and temperament but also the different times and political circumstances in which they found themselves. The qualities that distinguish Welty's photographs (and her

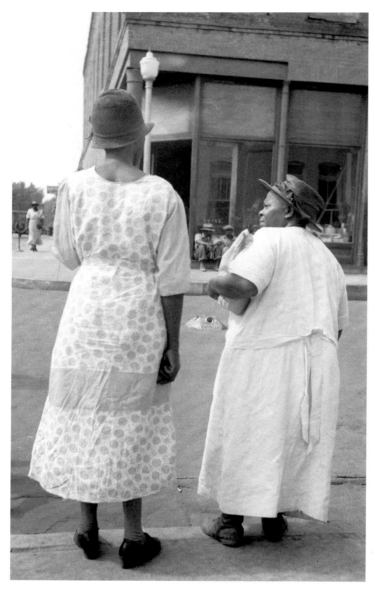

Street scene, Utica, MS, 1930s. Photo by Eudora Welty. Copyright © Eudora Welty, LLC. Courtesy Eudora Welty Collection—Mississippi Department of Archives and History.

The subjects in her photographs, black and white, realized it too, however reluctant the latter were to accept the fact.

Placing Mars's work in the context of Welty and the photographers of the FSA raises one other set of questions. What are the ethics of photographing the poor? When does sympathy for the suffering of others devolve into voyeurism? Can the documentary photographer represent the dispossessed without becoming, in some fashion, complicit in their abjection? These questions have provoked considerable debate in recent years, amidst changing laws and ethical norms about photography and individuals' ownership of their own images. Beloved works such as Dorothea Lange's *Migrant Mother*, perhaps the most iconic photograph in American history, have come in for more critical scrutiny. Identified by Lange only as a destitute mother of seven in a California pea-pickers' camp, the woman in the photo, belatedly identified in the 1970s as Florence Owens Thompson, derived no profit from the oft-reproduced image. Indeed, it was decades before she saw it. (According to Thompson, Lange promised to return with a copy of the photo but never did.) Nor is Lange the only celebrated American photographer to come in for retrospective criticism. The right-angle lens that Ben Shahn attached to his Leica in order to photograph people without their knowledge would today be considered unethical, in some contexts even illegal. The same could be said of the camera that Walker Evans secreted inside his overcoat to produce his acclaimed New York subway portraits.[24]

Mars's work is exempt from at least some of these concerns. Such was the closeness of Neshoba County that she knew most of the people she photographed, many of them quite well. She routinely shared prints with her subjects and appears never to have sold a photograph for money. While she occasionally took candid shots, her portraits are almost all formally posed; people in them know that they are being photographed. They look directly into and through the lens, fastening the viewer's eyes with disarming, almost painful frankness.

Yet questions linger. What options did a black person in Jim Crow Mississippi really have when confronted by a white woman with a camera? What words were exchanged? Do the faces in the frames really express frankness or simply the studied impassivity with which black Mississippians had learned to navigate a perilous white world? Mars occasionally reflected on her subjects' motives, most notably after an experience she had traveling in Europe in 1962. Spying a group of Parisians washing their clothes in the Seine, she reached for her camera, only to be angrily rebuffed. The response "was so unlike the black folks in Mississippi" that she found herself wondering if they too "had wanted to chase me." For better or worse, none ever did. In the end, she remembered only one

fiction)—wry humor, a love of the quaint and whimsical, a beguiling timelessness—bespeak a certain political innocence: whatever her private feelings about the racial order in which she lived, neither she nor her subjects imagined that it would change anytime soon. Mars, in contrast, answered the call to photography precisely because she understood that the Jim Crow system in which she had been raised was dying.

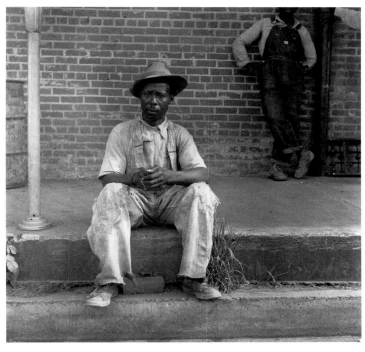

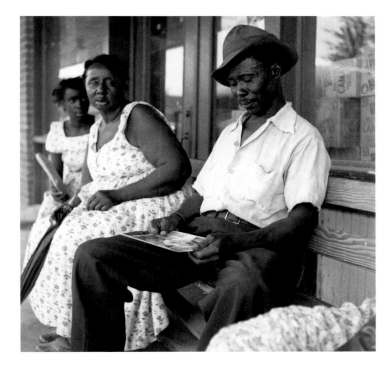

John Mack Bell on Philadelphia's courthouse square, 1955; Bell inspecting his portrait a week later.

occasion in which she was prevented from taking pictures in Mississippi and that by an enraged white landowner, who caught her photographing an elderly black woman on the porch of a tenant's shack on his farm. The experience was sufficiently traumatic for Mars that she went several months without touching a camera. What the episode meant to the old woman, who watched the dispute in silence, is impossible to know.[25]

◆　◆　◆

The launch of Mars's photographic career coincided with the US Supreme Court's decision in the *Brown v. Board of Education* case. In a unanimous ruling, the court declared that the system of racial segregation prevailing in the southern states since the 1890s was unconstitutional, igniting a political firestorm all across the South. Nowhere did the fire burn more fiercely than in Mississippi. US Senator James O. Eastland, soon to ascend to the chairmanship of the Senate Judiciary Committee, decried the ruling as a "monstrous crime," part of a Communist plot to destroy "our Republican form of government" and ensure "the mongrelization of the white race." "You are not required to obey any court which passes out such a ruling," he declared. "In fact, you are obligated to defy it." Eastland's native Sunflower

County became the seedbed of a new organization, the White Citizens' Council, which pledged to do precisely that. By the end of 1955, the council boasted chapters across the South—it claimed over one hundred thousand members in Mississippi alone—all committed to defending the southern "way of life" against integrationists and their Communist allies.[26]

Composed of businessmen, bankers, and other local notables, the Citizens' Council posed as a moderate alternative to groups like the Ku Klux Klan; its preferred weapon was economic coercion rather than rope or rifle. But the organization's apocalyptic rhetoric was an incitement to violence, and violence was not long in coming. In Humphreys County, the council launched a campaign against George Lee, a black minister and businessman working to register black voters. Lee, who refused to buckle to the pressure, was assassinated by unknown assailants in April 1955. In early August, another voting rights activist, Lamar Smith, was gunned down on the courthouse steps in Brookhaven, seat of Lincoln County, in front of dozens of witnesses, including the local sheriff. Three men were arrested for the crime, but an all-white grand jury refused to return indictments. Though initially spared the worst of the violence, Neshoba County was hardly immune to the fever. Copies of the Citizens' Council's monthly newspaper appeared in local mailboxes, and black

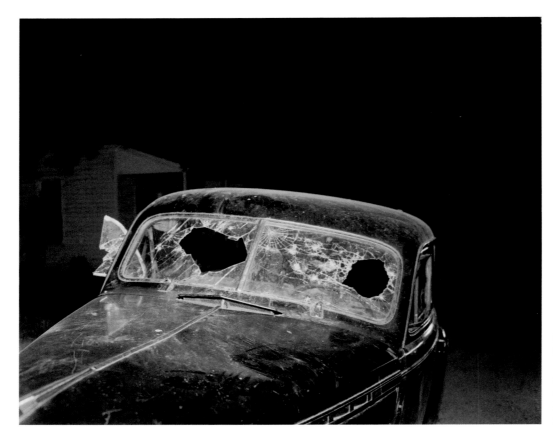

Reverend George Lee's bullet-riddled car, outside Belzoni, MS, May 1955. Photo by H. C. Anderson. Collection of the Smithsonian National Museum of African American History and Culture. © Smithsonian National Museum of African American History and Culture. 2007.1.72.6.

people suspected of political activity lost jobs and saw credit lines canceled and mortgages called in. The ordinary decencies that Mars had imagined to prevail in daily life withered, replaced by narrower, nastier qualities—suspiciousness, violent hostility to "outsiders," fantasies of persecution, as if white Mississippians were somehow the victims of a grievous crime. It was, she later wrote, as if the whole state had suffered a "mass nervous breakdown."[27]

The continuing white reaction to the *Brown* decision confirmed Mars's photographic vocation. It also prompted her, for one of the few times in her life, to try to share her photos publicly. In 1955, she entered a *Life* magazine photo-essay contest. She submitted twenty or so images, mostly Philadelphia street scenes, accompanied by a thousand-word essay entitled "The Story of the Southern Negro: Who He Is; What He Is, What He Stands to Lose through Integration." The bid was unsuccessful—the winning entry featured color photographs of birds in flight—and in later years she almost never mentioned the episode, which she

clearly found embarrassing. "[I] realized that my black and white photos were not what the magazine was looking for," she said simply, "and besides the writing was amateurish." But the contest entry, several draft versions of which survive in her personal papers, is worth closer examination, if only because it represents her first attempt to articulate the meaning of the reality she saw coming into focus in her camera lens.[28]

As the essay's long subtitle suggests, Mars positioned herself as a critic of integration. But her critique bore little relationship to the familiar catechism of segregationists. For Mars, the issue was not whether black people were entitled to exercise full civil and political rights—it was obvious to her that they were. Still less was she concerned with preserving the "southern way of life," some halcyon, harmonious racial order she knew to be imaginary. Her concern, rather, was with what integration portended for the future of black people themselves. Living in the most "adverse circumstances" imaginable, black southerners had "survived with dignity and poise." They had evolved qualities of character—moral

stamina, resiliency, humor, courage, adaptability—that not only ensured their own survival but also enriched the whole culture of the South. The danger, Mars wrote, was that "the Negro," in adapting to the culture and institutions of white America, would be tempted to "lose himself in the group," even to commit a kind of "racial suicide." Far from a reactionary defense of segregation, Mars's essay in some ways anticipated the cultural nationalist critique of integration that would emerge in the Black Power era of the late 1960s, although activists of that period would surely have bristled at the paternalistic way in which she made the case.[29]

As if her idiosyncratic musings on integration were not enough to doom her entry, Mars devoted the final section of the essay to white reactions to the *Brown* decision. If white people were indeed persuaded of their racial superiority, she asked, why were they so threatened by integration? What lay at the root of their fear? "There needs to be an answer," she pleaded, "because the conduct is irrational." Drawing on her experience in psychotherapy, she broached several possible explanations—guilt, shame, repressed sexual attraction—only to conclude that the sources of white fear remained "obscure." Small wonder that the editors of *Life* (which claimed more than a million subscribers in the southern states) preferred "Wild Birds in Flight."[30]

◆ ◆ ◆

Even as she worked on her submission, Mars continued to make photographs. Some of the most poignant were taken at the Neshoba County Fair. The origins of the fair, Mississippi's famed "Giant Houseparty," reach back to the 1880s, when residents of the Coldwater community southwest of Philadelphia convened for a combination camp meeting and agricultural fair. It quickly became an annual event. Wagons and makeshift tents soon gave way to permanent cabins, initially a few dozen and eventually hundreds, erected on a sprawling fairground, complete with midway, racetrack, stables, and pavilion. By the time Mars was born in 1923, the traditions of "fair week" were firmly entrenched. Families moved out to the fairground for a week of parties and gossip, harness racing, and carnival rides, culminating on the final night with a community sing-a-long on Founders Square. Although subject to the laws and customs of segregation, the fair was never a lily-white affair. White families brought along their black maids to cook, clean, and mind the children. Black men tended the grounds and groomed the horses. Choctaws from the nearby reservation came to sell their wares, adding another hue to the assemblage.[31]

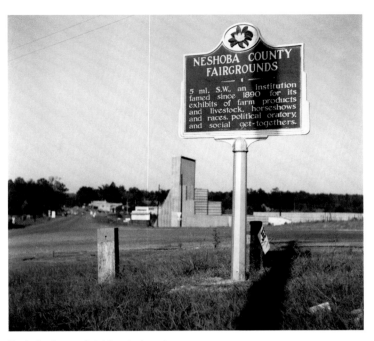

Neshoba County Fair historical marker, 1955.

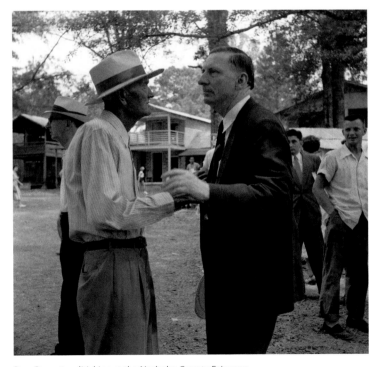

Ross Barnett politicking at the Neshoba County Fair, 1955.

Politicians followed. Staged a week or two before "first primary," start of the process by which the state's dominant Democratic Party nominated candidates, the fair became a mandatory stop for anyone seeking elective office, whether on the local school board or in the US Senate. The lions of segregation—Eastland, Vardaman, Bilbo—all took the stump in the tin-roofed pavilion to extol southern tradition and praise the "salt of the earth" citizens of Neshoba County. In a state in which folksiness remained a form of political currency, a successful speech at the fair could swing an election.

Mars loved fair week—the "most wonderful event in my life every year," she called it—and she took pride in the fact that her maternal forbears, who came from Coldwater, had attended the inaugural gathering. The fair embodied all the things that she prized about her origins: tradition, family, place. But surveying the scene in 1955, she detected darker realities. Interactions that had once seemed frictionless were fraught and angry. Gertrude, standing at the door of the Mars family cabin, was accosted by a white passerby: "Get off the porch, nigger." Black people listening to the speeches—though barred from the pavilion itself, black people were customarily allowed to sit on benches outside—were shooed away. Listening to politicians' paeans to the "good people" of Neshoba County, Mars heard not just ordinary political pandering, but a celebration of insularity, an appeal to tribalism. With a statewide election in the offing and voters in a lather, candidates flaunted their white supremacist *bona fides,* none more extravagantly than Ross Barnett, a rumpled personal injury lawyer from neighboring Leake County, whose gift for homespun racial invective had catapulted him to the center of the gubernatorial race. (Defeated in 1955, Barnett would win the governorship four years later.) Returning to her cabin after Barnett's speech, Mars found Gertrude, who had listened over the pavilion loudspeakers, in tears. "Why does he hate us so much?" she asked.[32]

The photographs that Mars took at the 1955 fair bespeak her conflicted emotions. An image of barefoot children lining up for sno cones is a portrait of innocence, but the figure of Ross Barnett buttonholing a voter, even as he looks over the man's shoulder in search of another target, is jarring, almost obscene. A white carnival worker pumps water for a black woman, a simple human gesture that, in the context of the time, assumes an aura of holiness. Taking photos from the balcony of her cabin late one afternoon, Mars looked across to a neighbor's balcony, where a black woman washed a naked white child in a galvanized bucket, a tableau encompassing all the complexity and contradiction, intimacy and injustice, of Mississippi's racial order. Printing the image later in her

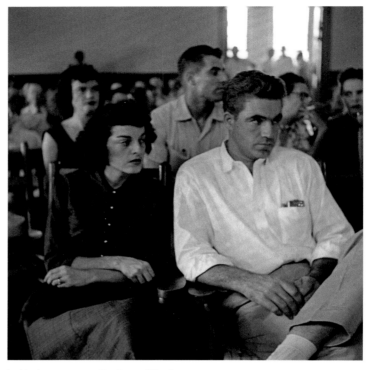

Inside the courtroom: Carolyn and Roy Bryant.

darkroom, she penciled a caption on the back: "Certain things are taken to be self-evident." The implied question, of course, is what happens when they are not? What happens when we trouble to see?

Emmett Till was murdered three weeks later. A fourteen-year-old boy from Chicago, Till was visiting relatives near the Delta town of Money when he was abducted, tortured, and shot after allegedly flirting with a white woman store clerk. His battered body, barely recognizable as human, was recovered from the Tallahatchie River three days later, still tied to a cotton gin fan. In contrast to previous killings, the murder provoked an international outcry, partly because of Till's age but also because of the condition of his body, revealed to the world after his mother, Mamie, insisted on an open-casket funeral. State officials, under intense pressure, promised a vigorous prosecution, and a scant three weeks later, two local men, Roy Bryant, husband of the offended store clerk, and his half-brother, J.W. Milam, stood trial in the Tallahatchie County Courthouse in Sumner on charges of kidnapping and murder. Journalists, photographers, politicians, and other interested observers from across the nation packed into the sweltering courtroom to watch the proceedings.[33]

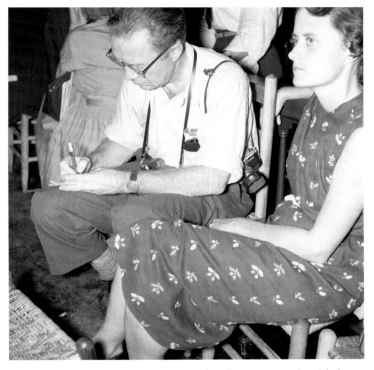

Betty Pearson and Ed Clark, a photographer for *Life* magazine, at the trial of Emmett Till's murderers, Sumner, MS, September 1955.

Mars was among the observers. She attended the trial in company with her old college roommate, Betty Bobo, now Betty Pearson, who lived with her husband on a plantation a few miles south of Sumner. Pearson had wrangled a pair of press passes from an in-law, and she and Mars took their seats inside the bar of the courtroom, alongside journalists, jurors, attorneys, and defendants. An acquaintance of Pearson tried to stop them at the door—"You will be hearing things that no white lady should hear," he warned—and save for the court stenographer, the defendants' wives, and one or two others, they were the only white women in the courtroom.[34]

Despite the gruesome circumstances, Mars watched the proceedings with hope. The judge was fair, the prosecution earnest, and for a time it seemed that justice might prevail, that Mississippi might at last reveal a different, decent face to the nation and world. But such hopes were swept away by the defense's closing argument. Convict these "outstanding men" of this "supposed crime . . . and our forefathers would turn over in their graves," the lead defense counsel warned jurors, adding: "I'm sure

every last Anglo-Saxon one of you has the courage to do the right thing." And indeed they did, taking just over an hour to return a verdict of not guilty. ("We wouldn't have taken so long if we hadn't stopped to drink pop," one juror later quipped.) In a final affront, Bryant and Milam proceeded to sell their stories for $4,000 to *Look* magazine, casually describing Till's last hours and their own feelings of rectitude. "I just decided it was time a few people got put on notice," Bryant declared. "As long as I live and can do anything about it, niggers are gonna stay in their place . . . Me and my folks fought for this country, and we got some rights."[35]

There is no shortage of images from inside the Till courtroom—the presiding judge allowed photography while the court was in recess—and many of the photos that Mars took have a familiar cast: the stone-faced jury; the defendants, flanked by their wives, looking bored. But with her keen eye, she also captured things that other photographers did not: Mamie Till entering the courtroom, an unlikely smile momentarily lifting her mask of grief; reporters clustered by a window, desperate for a breath of air; local whites gawking at the television crews, who gawk back at them; residents returning to the Sumner streets after an afternoon rain. In one image, a bespectacled black man stands outside the courthouse, next to a Confederate monument embossed with the words "Our Heroes," waiting for the jury to deliver its verdict, waiting to see whether white Mississippians, in their descent into racial madness, had come to abide the slaughter of children. A decade later, Mars would find herself standing a similar vigil.

◆ ◆ ◆

The racial fever that wracked Mississippi following the *Brown* decision spiked again in the Fall of 1962, after a federal court ordered the University of Mississippi to register an African American student, James Meredith. For Ross Barnett, now the state's governor, the court's decision marked "our greatest crisis since the War Between the States." "There is no case in history where the Caucasian race has survived social integration," he thundered in a statewide radio address. "We will not drink from the cup of genocide!" Inspired by such rhetoric, thousands of armed white Mississippians descended on the campus, where they engaged in a running battle with the federal marshals dispatched to protect Meredith. By the time the smoke and tear gas cleared, two men were dead and more than three hundred injured. The riot was news all over the world; Mars, traveling in Europe at the time, first learned of it from a front-page photo in an Italian newspaper. Piecing together reports of the episode after her

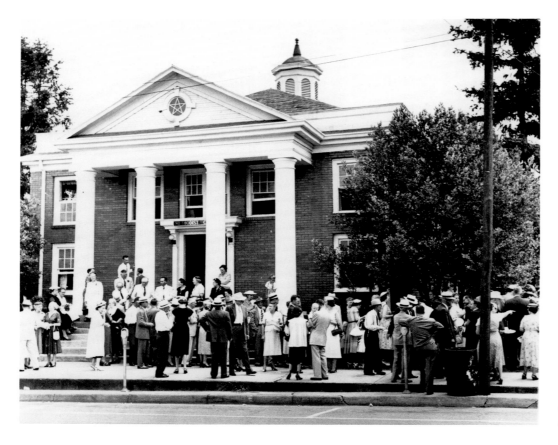

Congregation outside Philadelphia's First Methodist Church.

return, listening to her neighbors rage against meddling "outsiders," she grew more and more heartsick. "I found the attitudes when I returned almost incomprehensible," she later wrote. "It seemed to me that Mississippians had fully lost contact with reality."[36]

Given her feelings, one might have expected Mars to shake the red clay of Neshoba County from her feet for good. She did the opposite. In late 1962, she closed out her affairs in New Orleans and moved back to Philadelphia. She joined the local Methodist Church, which she had abandoned two decades before, and threw herself into the life of the community. Her decision surprised friends and family members, and Mars herself struggled to explain it. "A Southerner identifies with his region, his state and especially his home town," she wrote in a letter to a friend, citing the example of Faulkner. Even those who had "left the locale" or otherwise escaped the pressures of "tribal living" remained "emotionally involved." It also appears, based on journal entries from the period, that she had reached a point in her therapy where she felt

it necessary to return home and face the traumas of her childhood. But beyond these personal considerations, Mars clearly believed that she could play a constructive political role. Having lived so long on the border between insider and outsider, she saw herself as uniquely qualified to help fellow Philadelphians to understand and adapt to the changes they saw bearing down on them. "She wanted to be a leader in that town," recalled Betty Pearson, who strove to play a similar role in her own Delta community. "She felt really close to it."[37]

If Mars believed she could help to steer her hometown clear of the approaching tempest, then she was badly mistaken. The white citizens of Neshoba County steered straight into the storm. In the 1963 sheriff's election, nearly two-thirds of local voters cast their ballots for Lawrence Rainey, a brutal, rabidly racist man whose qualifications for office included having recently shot dead two unarmed black men. Rainey's campaign speech at the Neshoba County Fair was short and to the point: "My name is Lawrence Rainey. Y'all know me and if I'm elected, I'll take care of things

Mariah Moore, a plaintiff in the Burnside estate case, outside the Neshoba County Courthouse, May 1955.

for you." Neshoba County also proved a prime recruiting ground for the White Knights of the Ku Klux Klan, a violent splinter group founded by Klansmen frustrated with what they regarded as the moderation and passivity of the "Original Knights." The new organization announced its existence in the spring of 1964 when it simultaneously burned crosses in more than sixty of the state's eighty-two counties. Neshoba County topped the list with a dozen burnings, including one on the courthouse square and six in Independence Quarters, home to most of Philadelphia's black population. The episode elicited no condemnation from local officials and only the briefest mention in the *Neshoba Democrat,* the local newspaper, which printed a statement from Sheriff Rainey dismissing the cross burnings as "an attempt by outside groups to disrupt the good relations enjoyed by all races in this county." The attack on Mount Zion Church two months later elicited no comment at all. Had most white citizens of Neshoba County had their druthers, the murders of Chaney, Schwerner, and Goodman would have been treated the same way.[38]

In *Witness in Philadelphia,* Mars described her neighbors' response to the murders: the initial dismissal of the three men's disappearance as a "hoax," followed immediately by accusations against the men themselves: "This wouldn't have happened if they had stayed where they belong." "How long do you think we'd last in Harlem?" The book also recounted her efforts, along with a small "cell" of like-minded citizens, to rally the community, and of the suspicions that such efforts aroused. A pivotal moment occurred a few weeks after the disappearance, when a friend covering the case for a New Orleans newspaper invited Mars to accompany her on a visit to the COFO office in Meridian. A young black man accosted her at the door. "Do you think you're free?" he asked. As she stammered out a reply, he answered his own question: "You're not free. There's a man got your license plate the minute you came up those steps." He was right. By the time Mars got back to Philadelphia, word of her visit had already spread around town, and the rumor mill had begun to grind: "Florence has joined COFO." The months that followed brought surveillance and threatening phone calls, a Klan-orchestrated boycott of her stockyard, and a night in jail after a violent confrontation with Sheriff Rainey. Most painful of all was her forced resignation as class and youth leader at Philadelphia's First Methodist Church, following a campaign led by one of the congregation's lay leaders, a known Klansman. "What happened in that Methodist Church there nearly killed her," Betty Pearson recalled. "I mean that really hurt."[39]

What *Witness in Philadelphia* does not adequately convey is how thoroughly the case consumed Mars. Long after the FBI had found the bodies and made arrests, she continued her own investigation, desperate to understand not only the murders themselves but also the process by which an entire town, a town she knew to be full of kind, decent people, had retreated into complicity and denial. She filled notebook after notebook with observations and reflections. She read voraciously—Faulkner and Lillian Smith, Erich Fromm's *Escape from Freedom* and W. J. Cash's *The Mind of the South,* John Dollard's *Class and Caste in a Southern Town* and Willie Morris's *North Toward Home*—in search of insights. Hearkening to her Poppaw's admonition about knowing "the background," she researched the early history of Neshoba County, mining census records, collecting oral histories, reconstructing the origins of the county's early settlers, black and white. She called the work, only half facetiously, her "thesis."[40]

Unfortunately, the clarity of expression that characterized Mars's photography did not translate to her writing. She struggled to finish what she began and to find outlets for what she finished. *Witness in Philadelphia* was rejected by fourteen different publishers before she

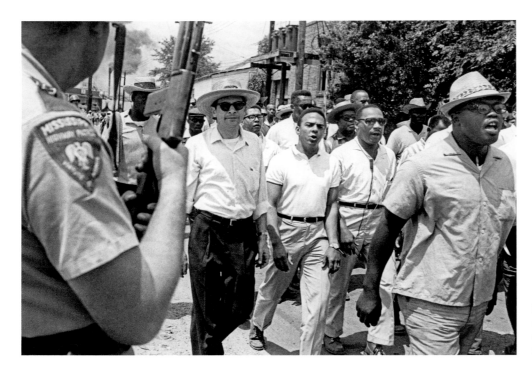

Martin Luther King Jr., Andrew Young, and other civil rights leaders marching in Philadelphia, June 1966. Photo by Bob Fitch. Courtesy of Stanford University Archives.

grudgingly hired an editor, Lynn Eden, who helped hew an acceptable manuscript out of the endless drafts. An intended sequel, *The Bell Returns to Mount Zion,* never found a publisher. *The Lake Place Burnside Family Story,* an account of a local court case involving the disputed estate of a wealthy mixed-race family, met the same fate. (She eventually had both manuscripts printed privately.) Though stung by the rejections, Mars continued to write, year after year, churning out thousands of pages of text. Neshoba County became for her what the fictional Yoknapatawpha County had been for Faulkner, a latticework of lives and stories, present and past, at once universal and intensely particular.[41]

One thing that Mars did not do much of after 1964 was take pictures. Even before the murders, the tense atmosphere made photography difficult. In their wake, it was well-nigh impossible. The clouds of fear and suspicion eventually dissipated, but by then she was consumed with her research and writing. "The writing took over from the photography in the middle of my life," she said simply. Though she still occasionally took out her camera, the impulse that had propelled her decade-long quest to create a visual record of her small corner of Mississippi was spent. Or perhaps she simply understood that the work was done, that the black and white world she had first glimpsed as a child, traversing the backroads of Neshoba County with her Poppaw, was well and truly gone.[42]

◆ ◆ ◆

Among the small number of photographs that Mars took after 1964 are portraits of civil rights workers, several of whom she interviewed for her research, a few of whom became close friends. Following the discovery of the murdered men's bodies, COFO student volunteers established a Freedom House in Independence Quarters, which they kept open for nearly three years, despite constant harassment by police and gun-toting night riders. Chastened by the fallout from her earlier visit to the COFO office in Meridian, Mars initially gave the students a wide berth, but as her ostracism continued, she began to seek them out. Where others saw "Communists" and "beatniks," she found kindred spirits, young people stepping outside the confines of their comfortable worlds, struggling to "get outside and see." A few of these relationships persisted even after the volunteers returned to their campuses. Gail Falk, a Radcliffe student who later became one of the first woman graduates of Yale Law School, hosted Mars during a memorable visit in the summer of 1968,

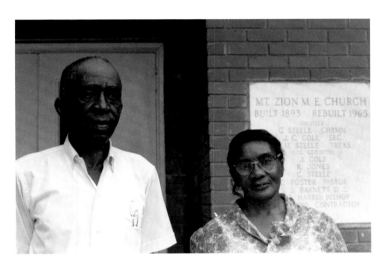

Bud and Beatrice Cole outside rebuilt Mount Zion Church, ca. 1966.

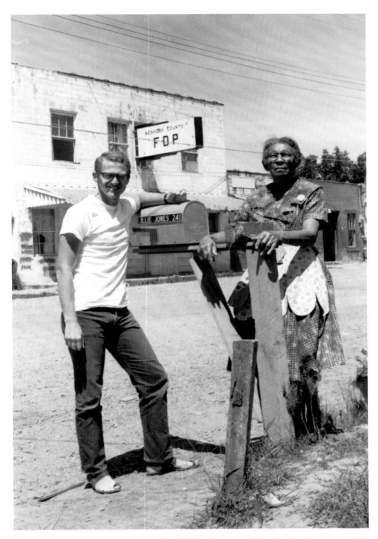

Alan Schiffmann (a.k.a. COFO Red) and Lillie Jones outside the headquarters of the Freedom Democratic Party, Independence Quarters, Philadelphia, MS, 1966.

a trip that included stops at the Newport Folk Festival, where they took in a performance by Janis Joplin, and the New York office of the Congress of Racial Equality, where Mars retrieved the bell from Mount Zion Church. Recovered from ruins of the burnt church, the bell had been taken north by COFO activists for use in fundraising, after which it was forgotten. Mars tracked it down and arranged its return to Mount Zion.[43]

Mars also forged enduring friendships with local people swept up in the civil rights struggle. Having vainly waited for townsfolk to "stand up," she was pleased to discover some who had been standing all along—individuals such as Clinton Collier, a minister and schoolteacher, who staged Neshoba County's first public civil rights rally just days after the bodies of the murdered men were unearthed, and later campaigned for Congress under the banner of the insurgent Freedom Democratic Party; Lillie Jones, the aged matriarch of Independence Quarters, who fed and sheltered the student volunteers; and Junior Roosevelt "Bud" Cole and his wife Beatrice, stewards at Mount Zion, who survived a brutal assault by Klansmen on the night they burned the church. For Mars, these relationships, far richer than those ordinarily afforded white and black Mississippians in the era of Jim Crow, represented a kind of recompense, a blessing wrung from the horror that had engulfed her hometown. They also offered her flesh-and-blood illustrations of the qualities she had labored to capture in her photographs—of resiliency, stamina, courage, and grace.[44]

All these qualities and more were on display on June 21, 1966, the second anniversary of the murders, when Reverend Collier led community members on a memorial march from Independence Quarters to Philadelphia's courthouse square, accompanied by Martin Luther King Jr. and other national civil rights leaders. A furious white mob met the marchers at the square, assailing them with rocks and bottles,

firecrackers and fists. King later described the episode as one of the two most terrifying experiences of his life. (The other came later that summer, marching in Chicago in support of open housing.) In the circumstances, King can be forgiven for overlooking the small woman standing silently on the square's elevated sidewalk, holding aloft an American flag in greeting.[45]

◆ ◆ ◆

Mars lived in Philadelphia for another forty years after the march—long enough to see some cracks appear in the wall of silence and denial. The publication of *Witness in Philadelphia* in 1977 awakened old animosities, but the bookstore on the square stocked the book, and it sold well. Mars was particularly gratified by the interest of young people, many of whom had heard little or nothing about the murders or their aftermath from their parents. One of those young people was Dick Molpus, who had observed the events of 1964 as a fourteen-year-old boy. On June 21, 1989, the twenty-fifth anniversary of the killings, Molpus, now Mississippi's secretary of state, formally apologized to family members of the murdered men in the name of his town, county, and state. Mars would also live to see the emergence of an interracial Philadelphia Coalition, which used the occasion of the fortieth anniversary in 2004 to demand

that the state of Mississippi finally prosecute the case, which it had contrived never to do. The state's attorney general complied, impaneling a grand jury, which returned a bill of indictment against the man who had orchestrated the murders, an aged Baptist minister and Klan kleagle named Edgar Ray Killen. Among the grand jurors was a woman, Johnnie Ruth Edwards, whom Mars had photographed half a century before—a little girl, grievously burned, standing with her family in the back of a flatbed truck, standing now for justice.[46]

On June 21, 2005, the forty-first anniversary of the murders, a Neshoba County jury declared Edgar Ray Killen guilty of three counts of manslaughter, for which he was sentenced to sixty years in prison. Among the spectators in the crowded courtroom was Florence Mars, who watched the proceedings from a wheelchair. Ravaged by diabetes and a recent stroke, her once cherubic face collapsed by Bell's Palsy, she rose from her sickbed for one last act of witness.

Mars died in April 2006. Her passing elicited tributes and testimonials in newspapers all over the country, from the *Neshoba Democrat* to the *New York Times,* a chorus of praise for a courageous woman. What the reports lacked was any consideration of what Mars would have called "the background," the confluence of place and time, character and circumstance, that allowed her to see what others could or would not. To understand that, look—really look—at her photographs.

PHOTOGRAPHS

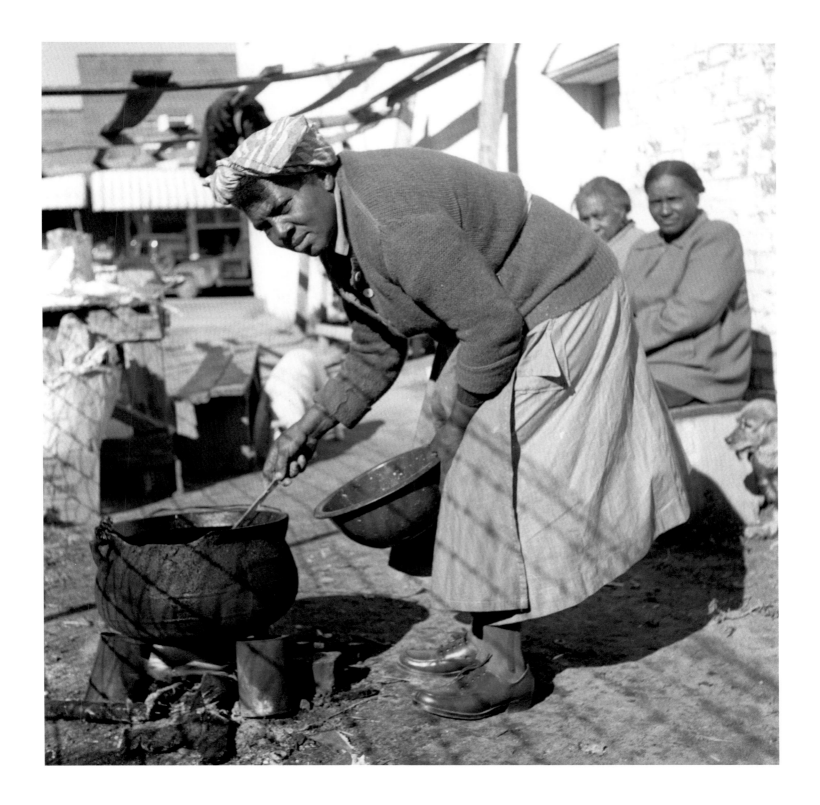

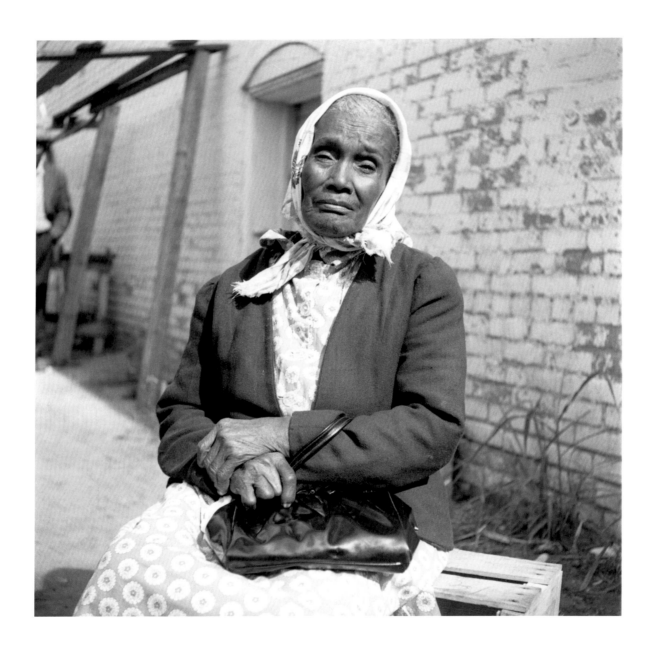

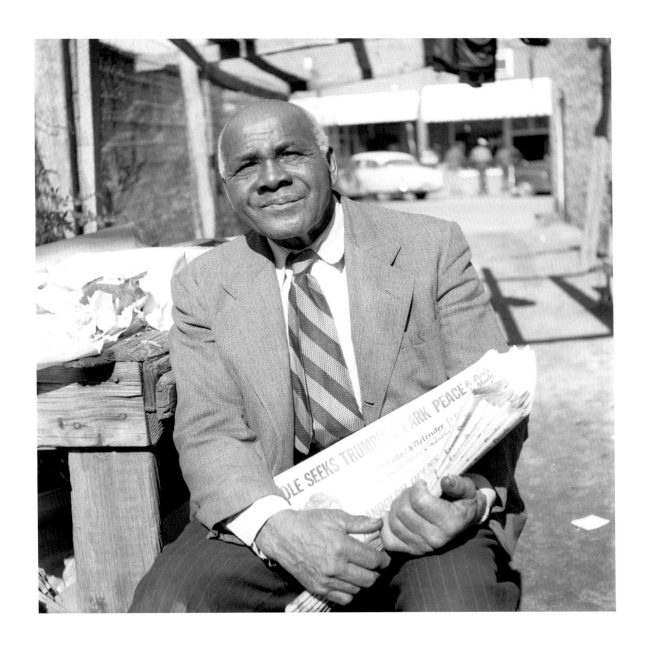

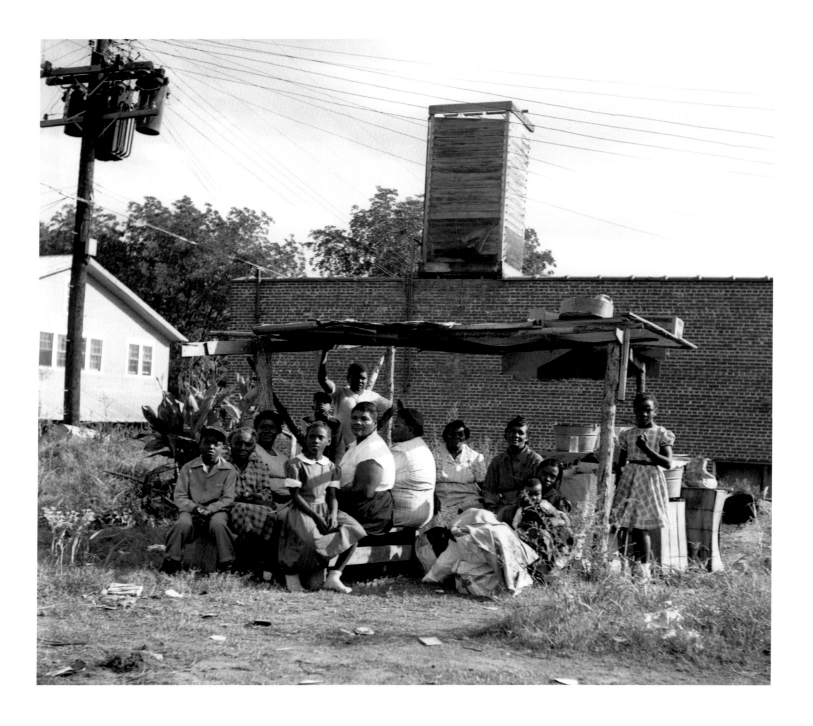

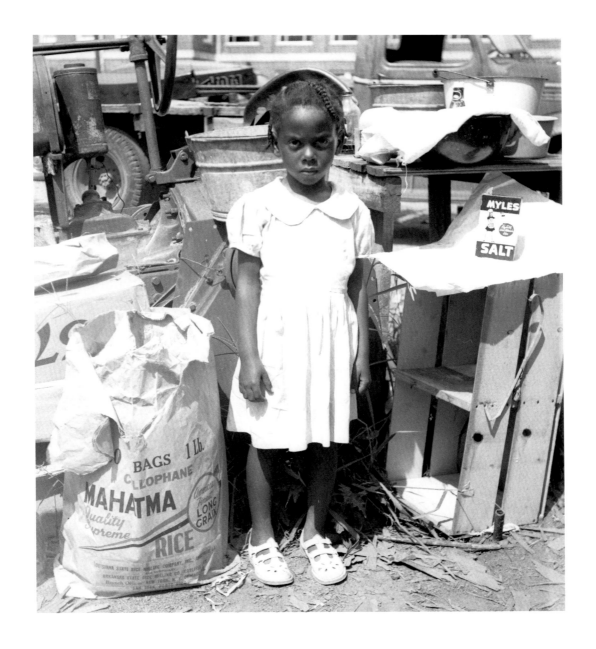

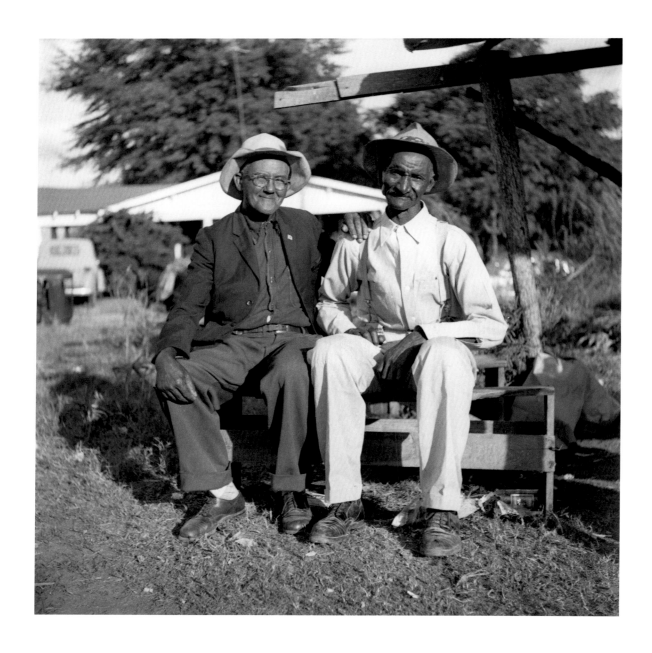

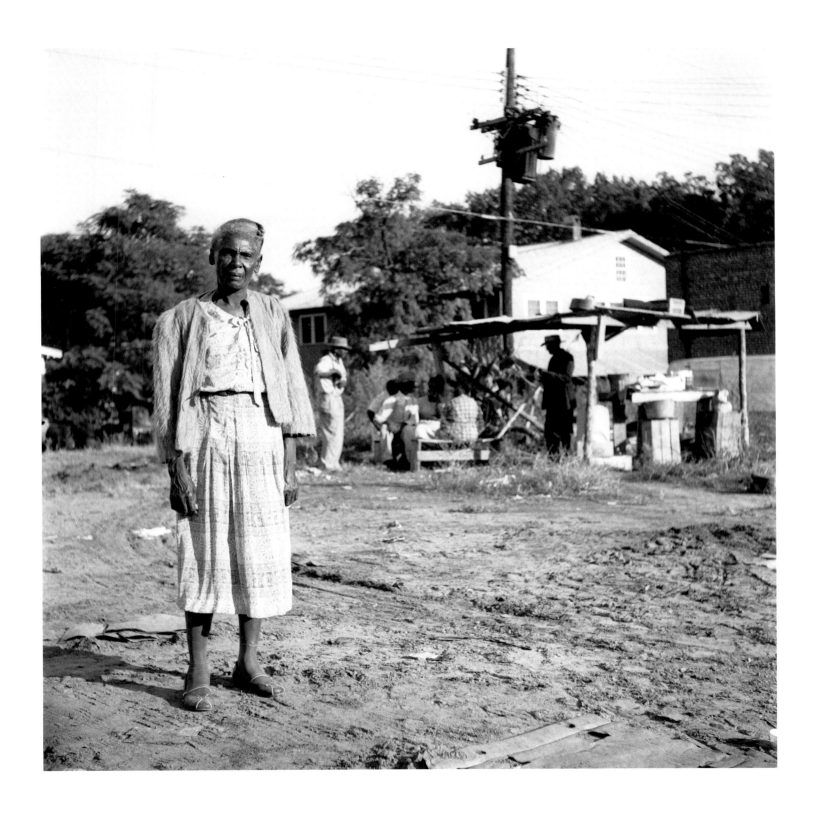

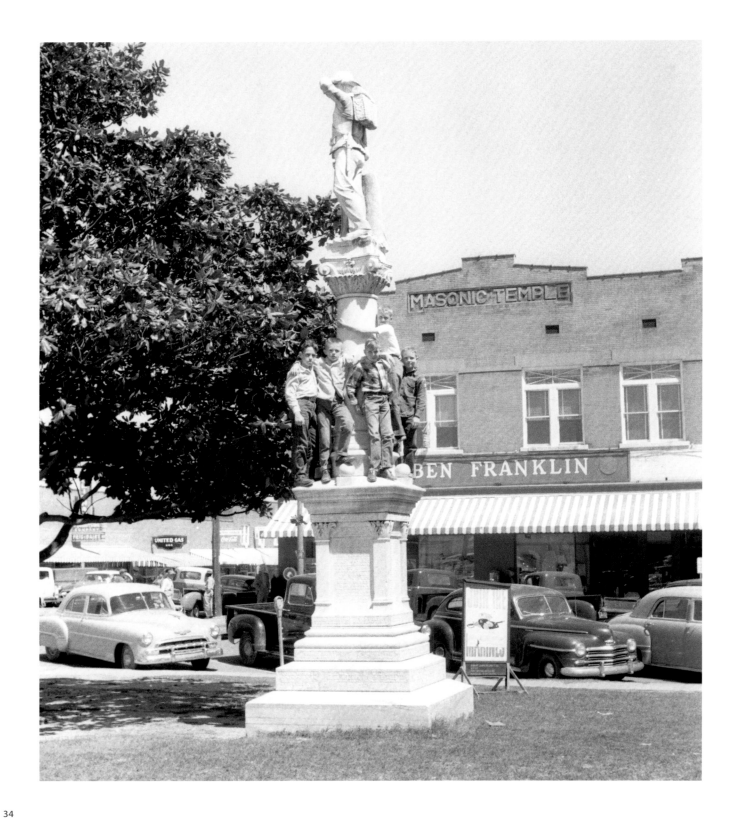

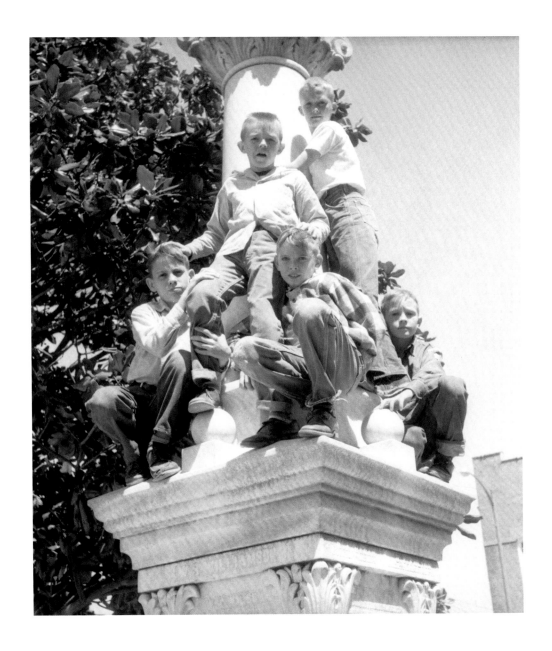

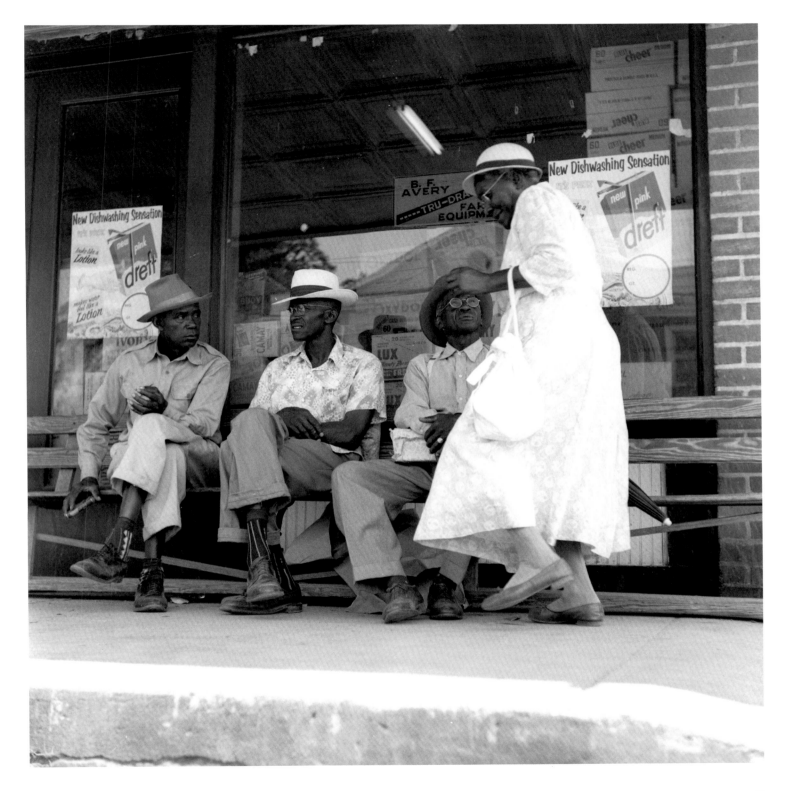

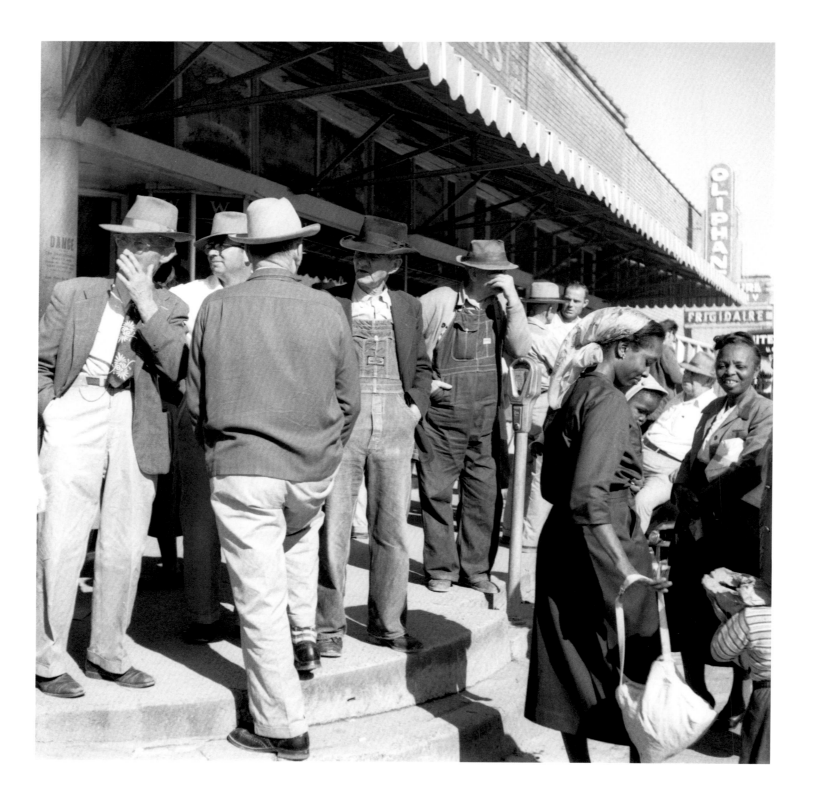

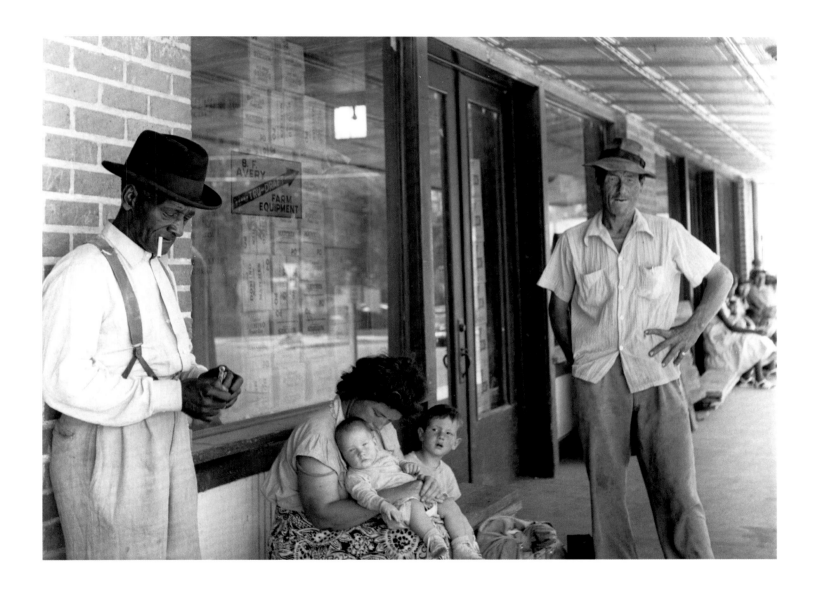

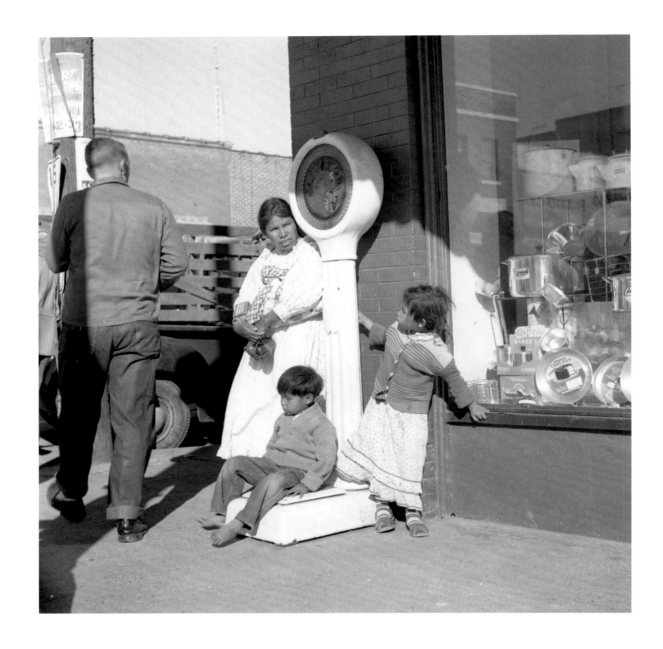

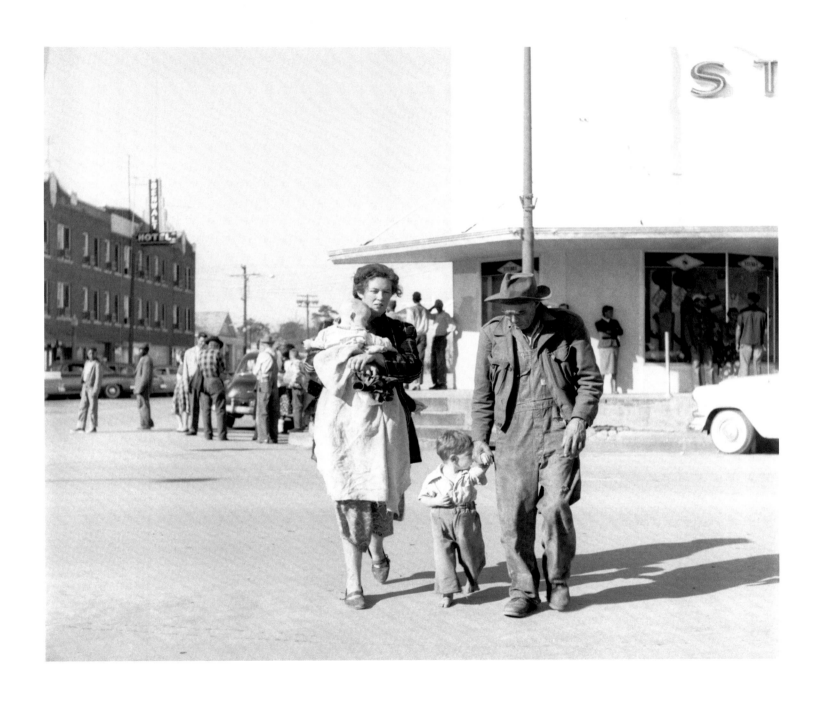

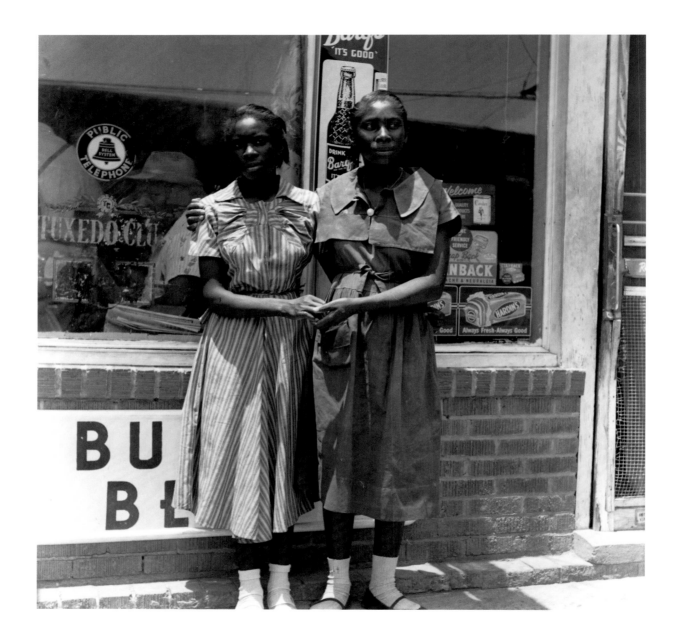

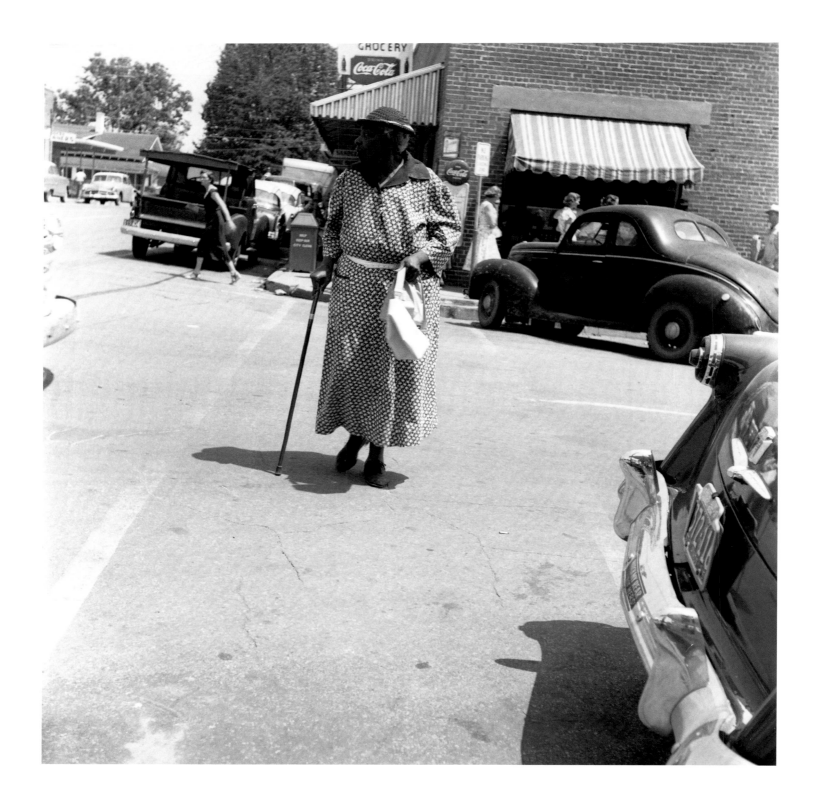

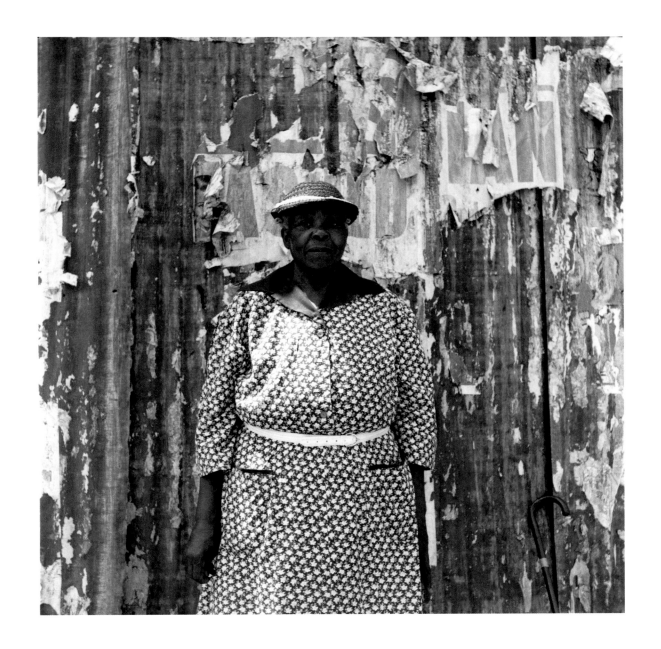

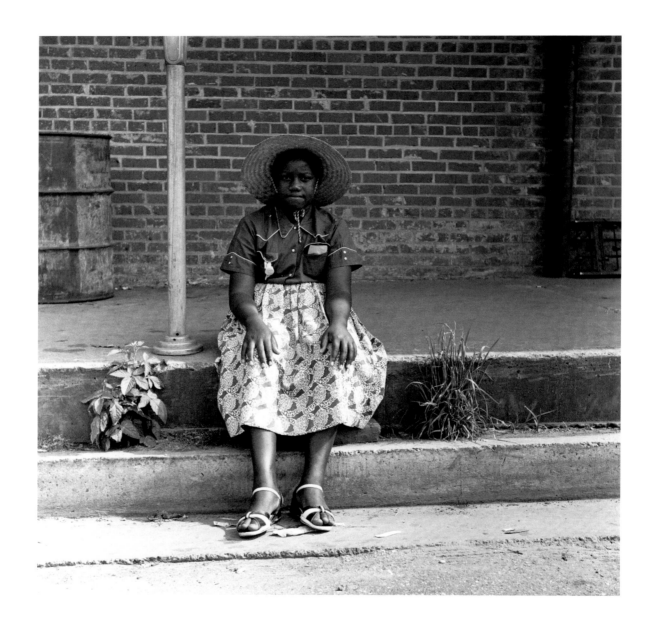

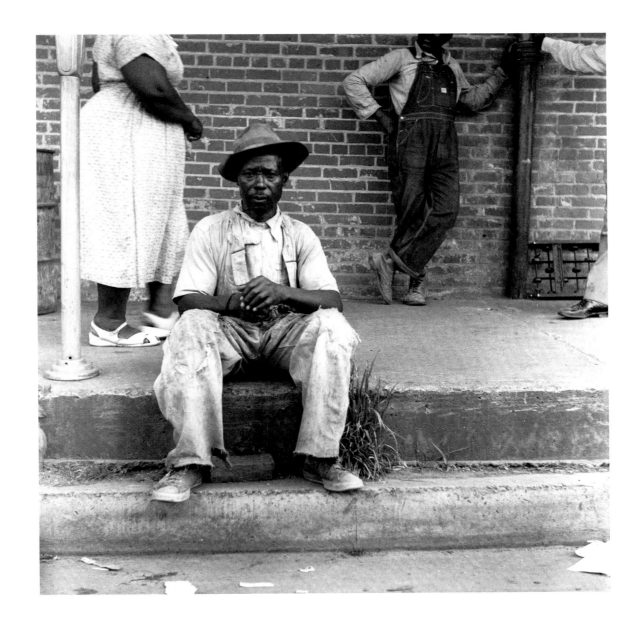

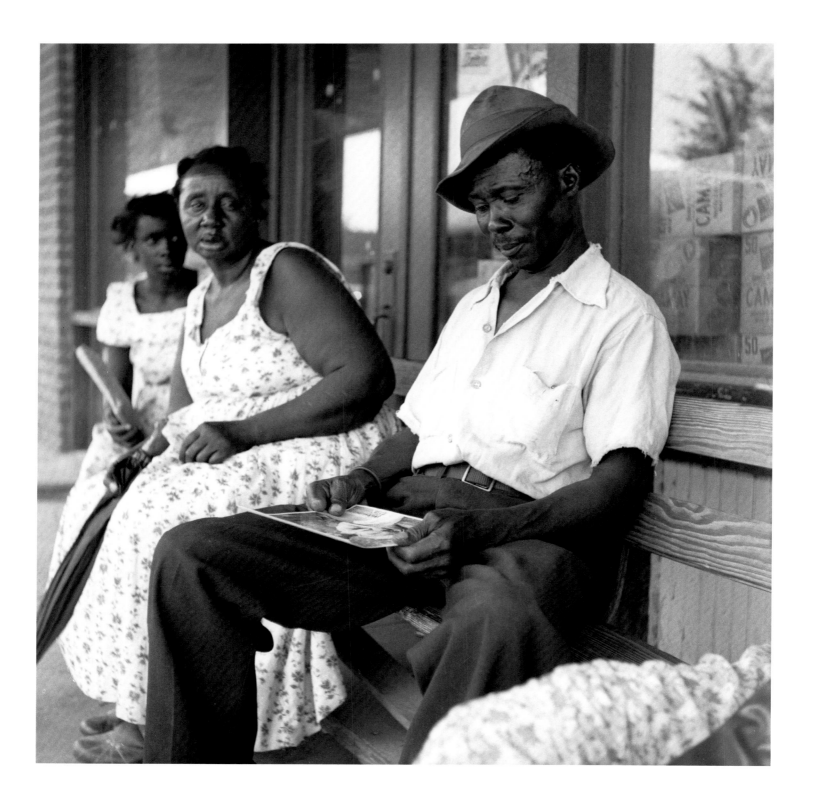

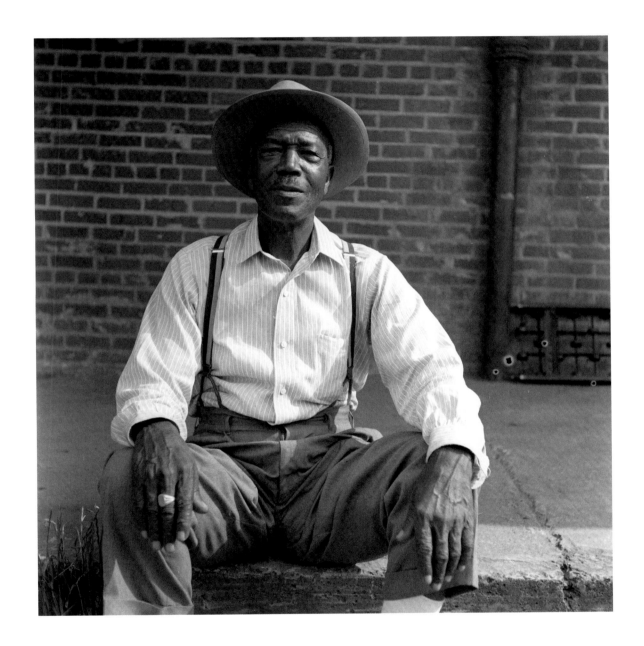

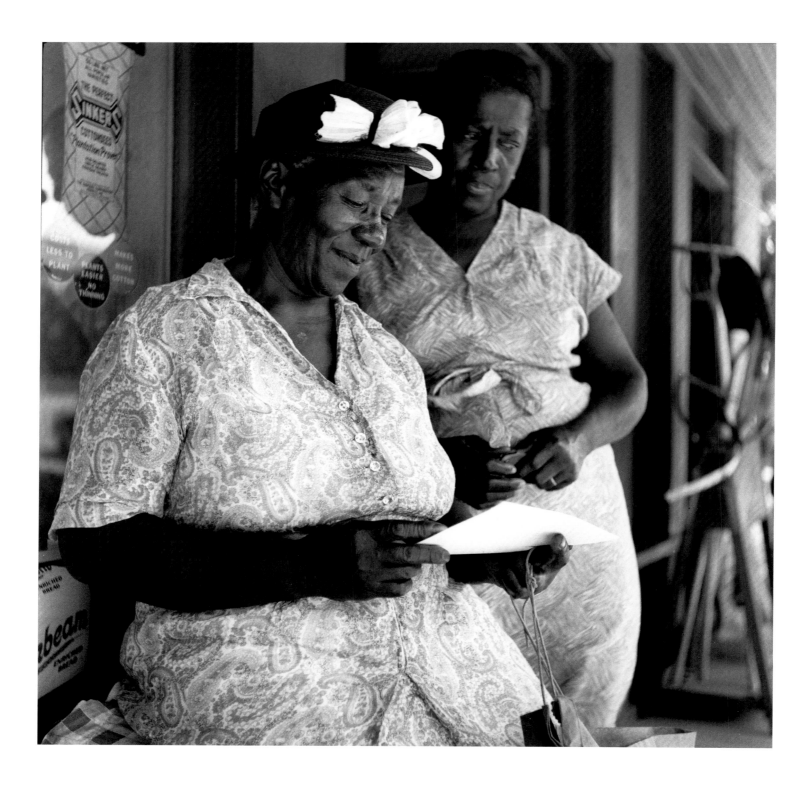

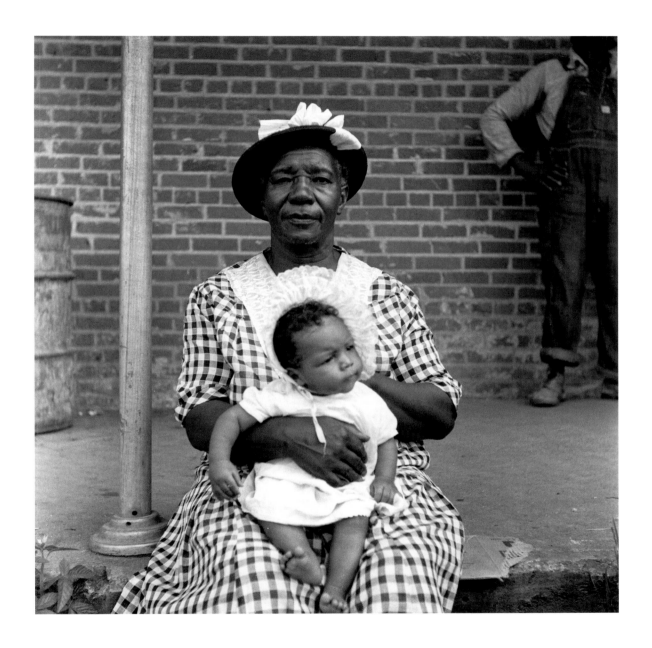

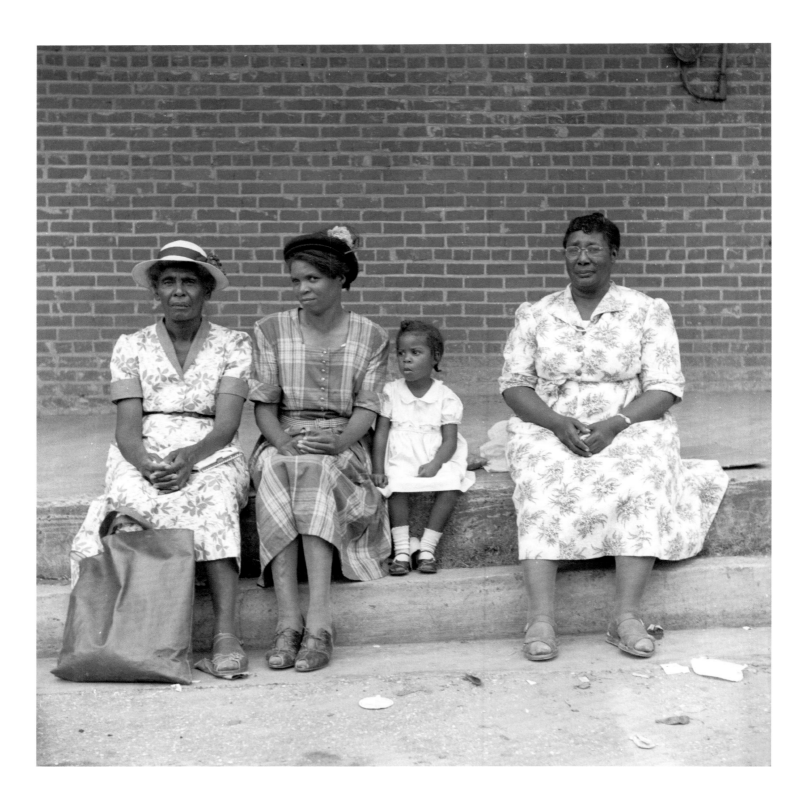

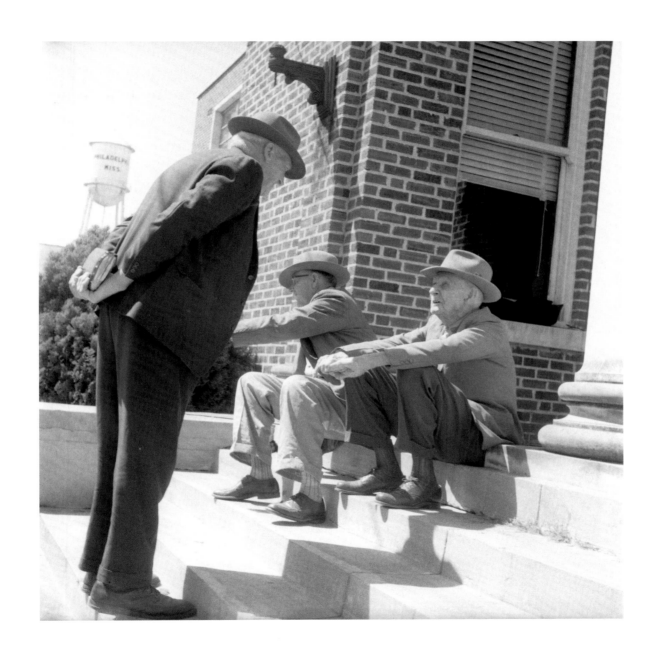

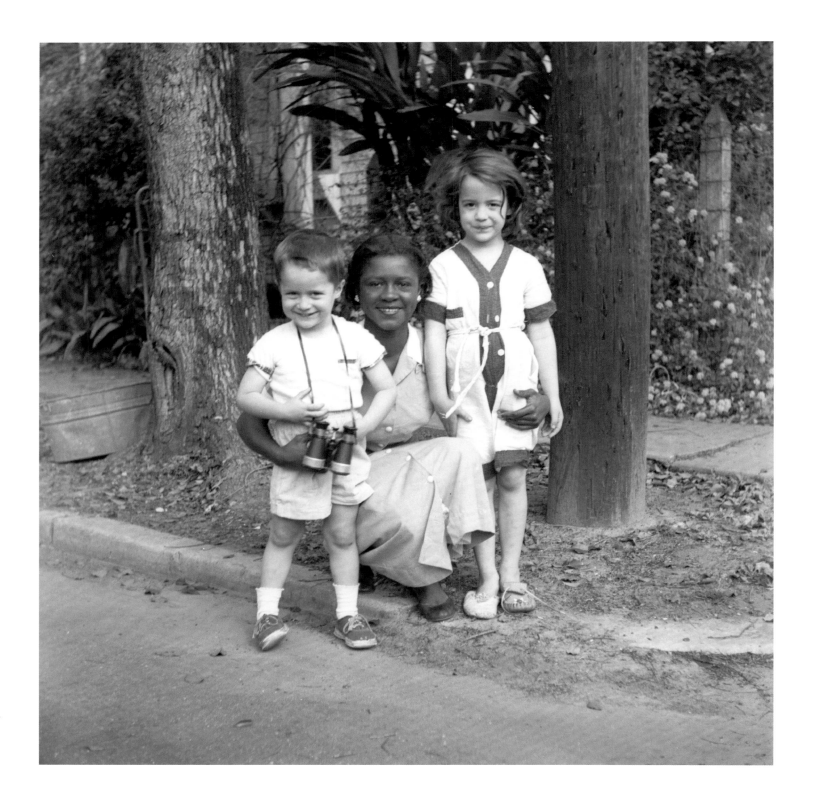

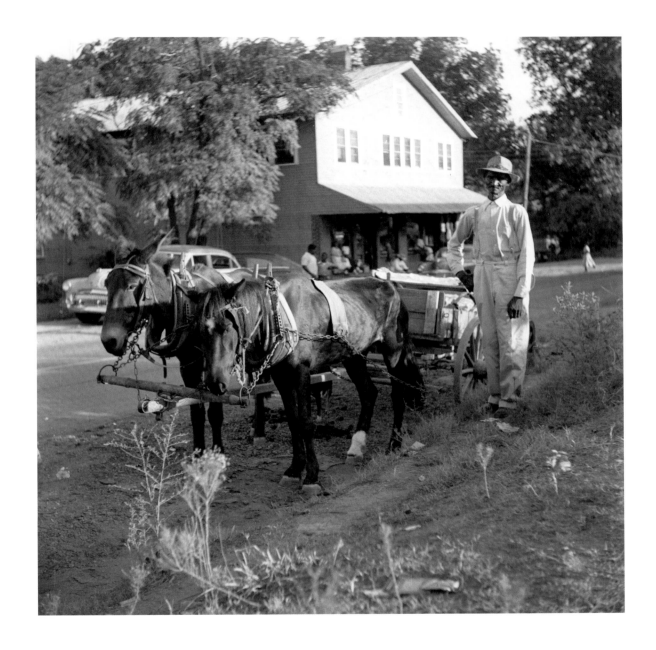

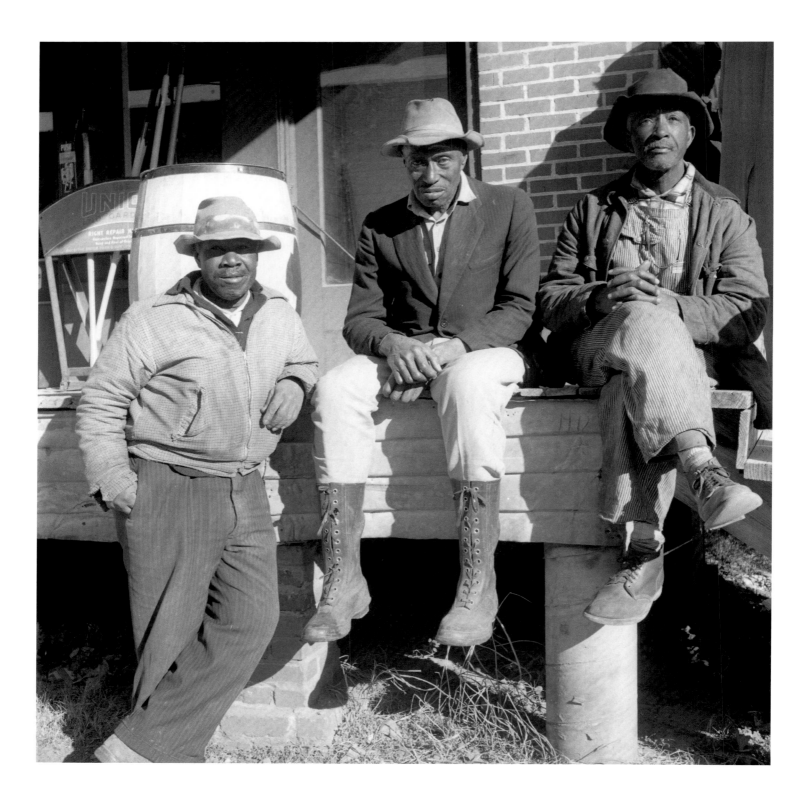

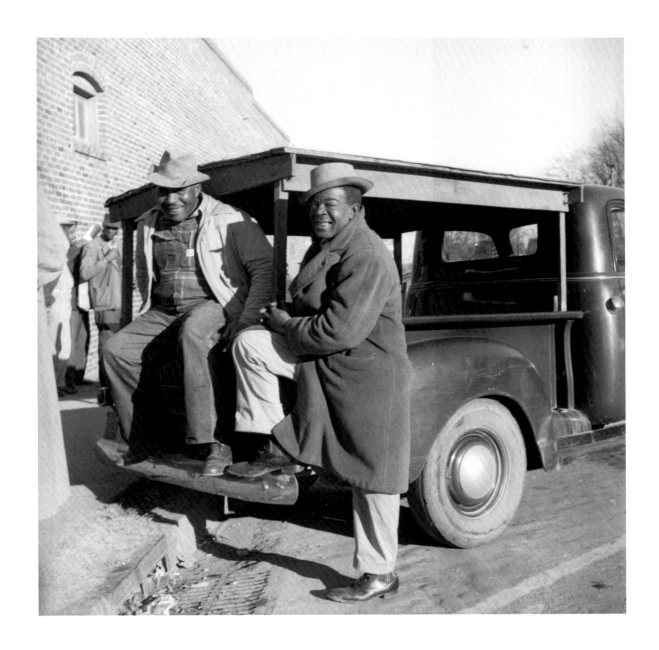

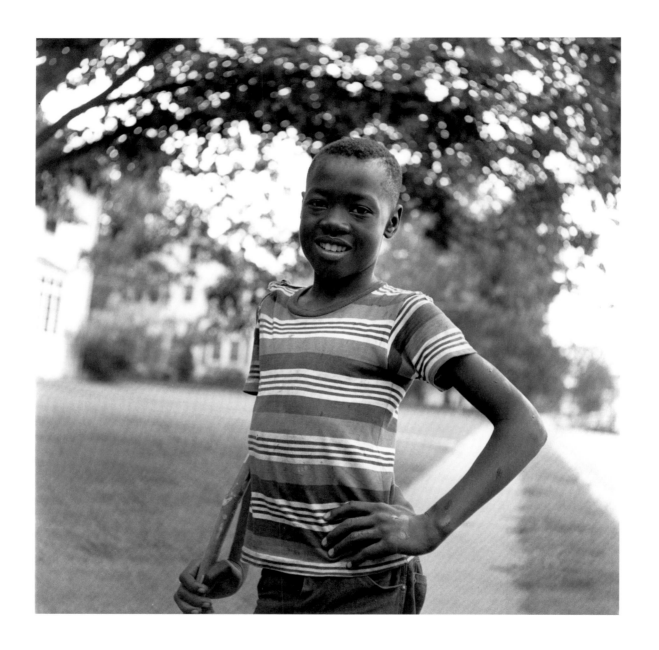

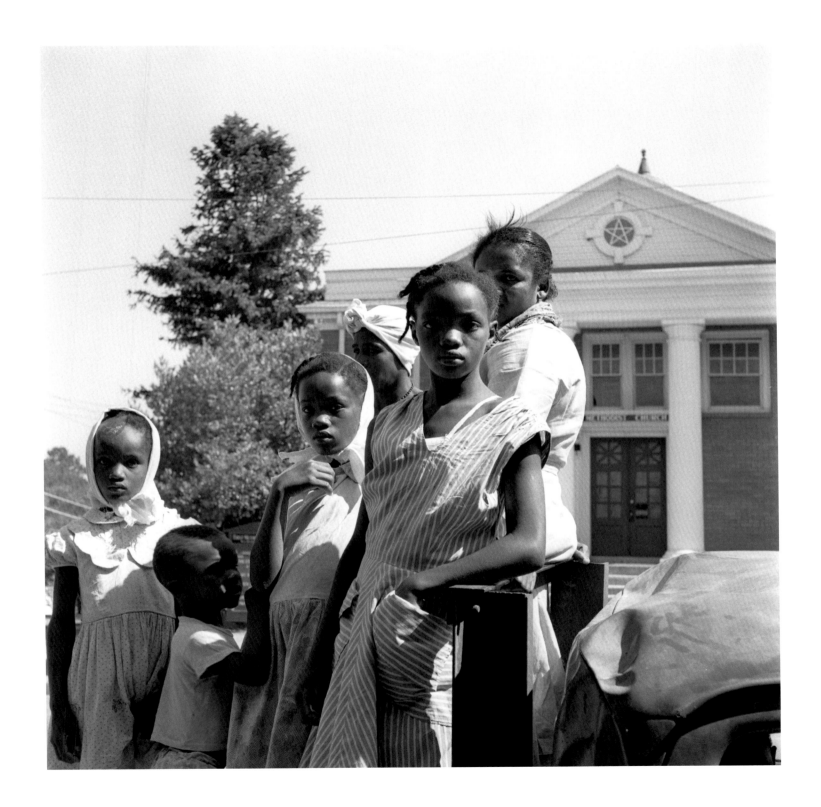

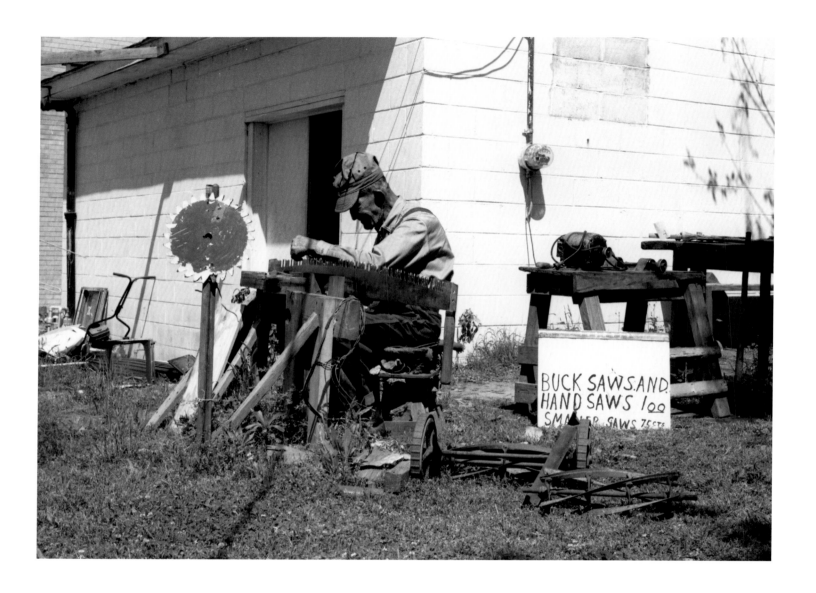

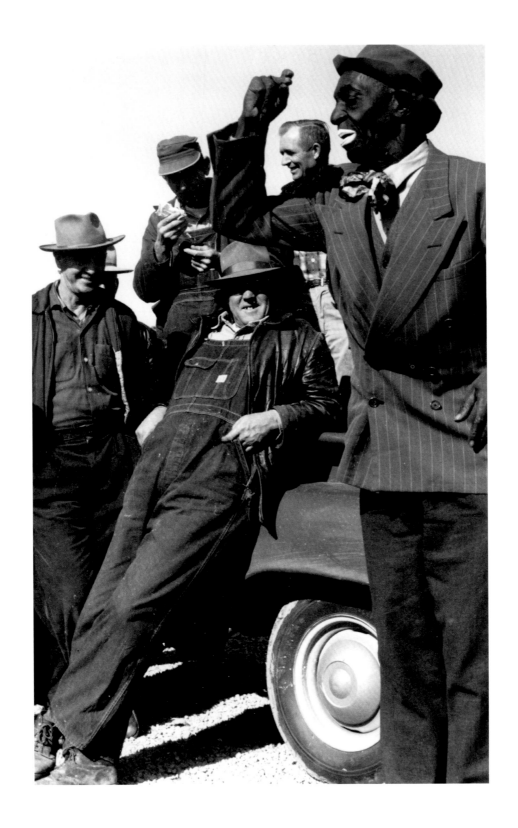

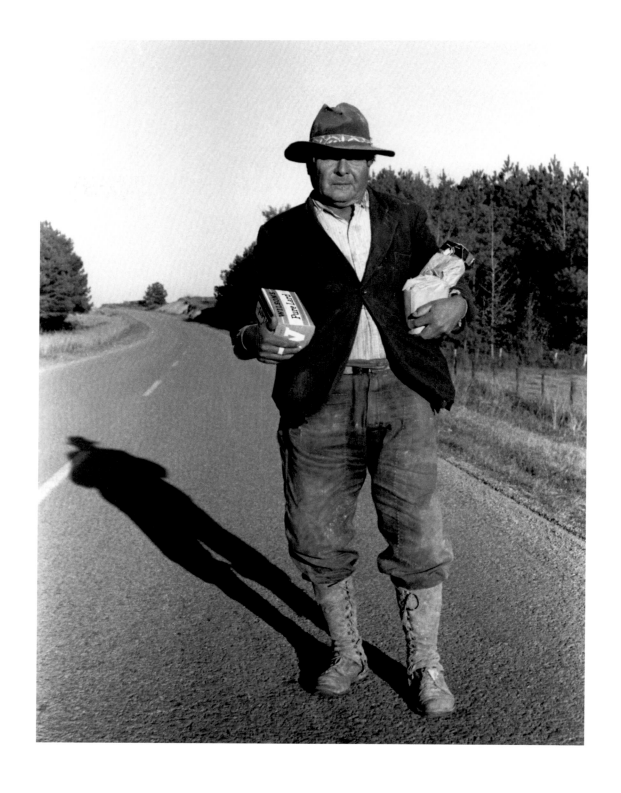

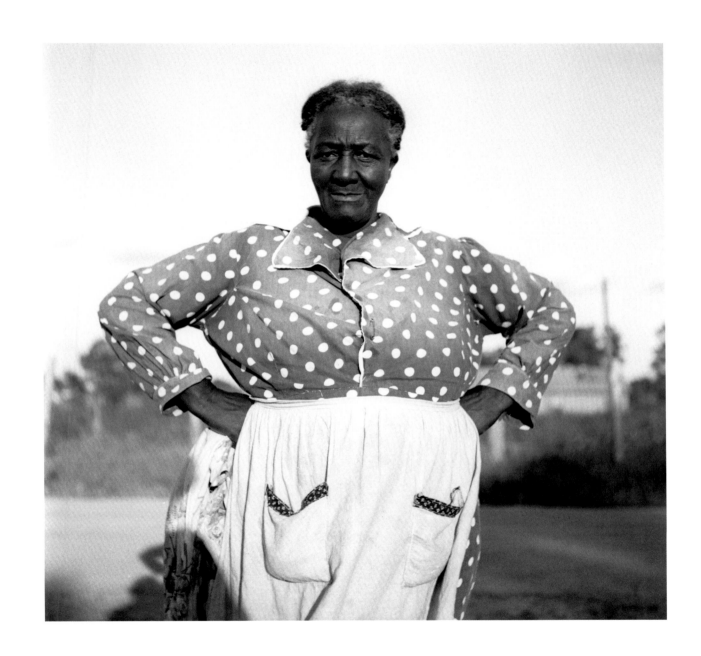

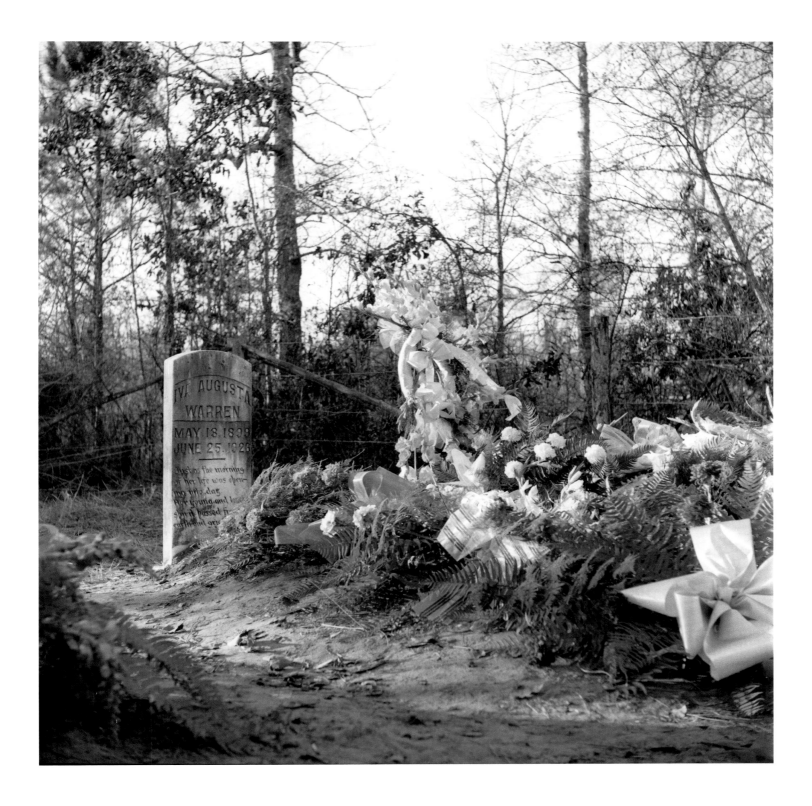

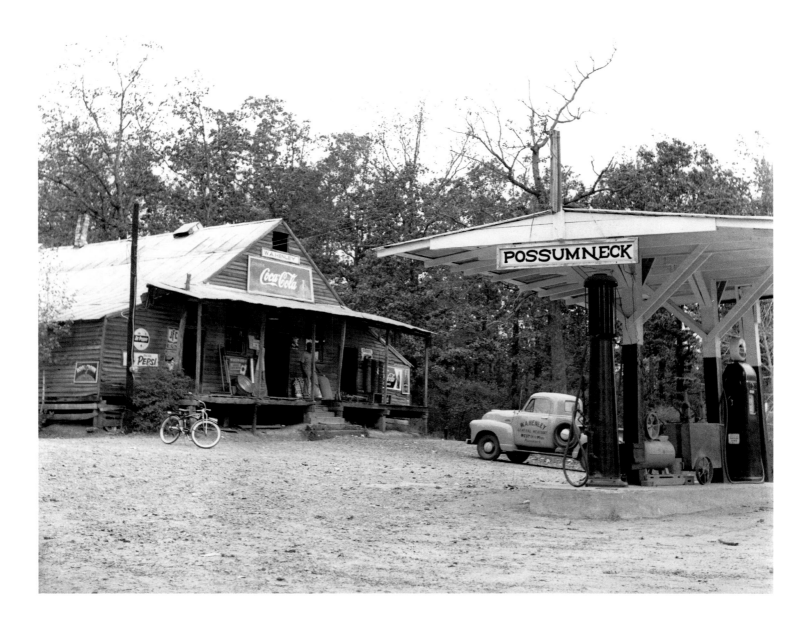

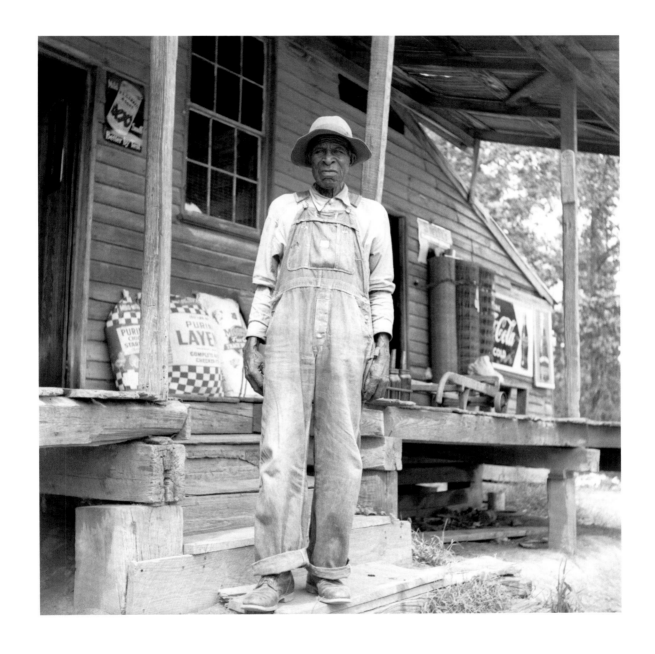

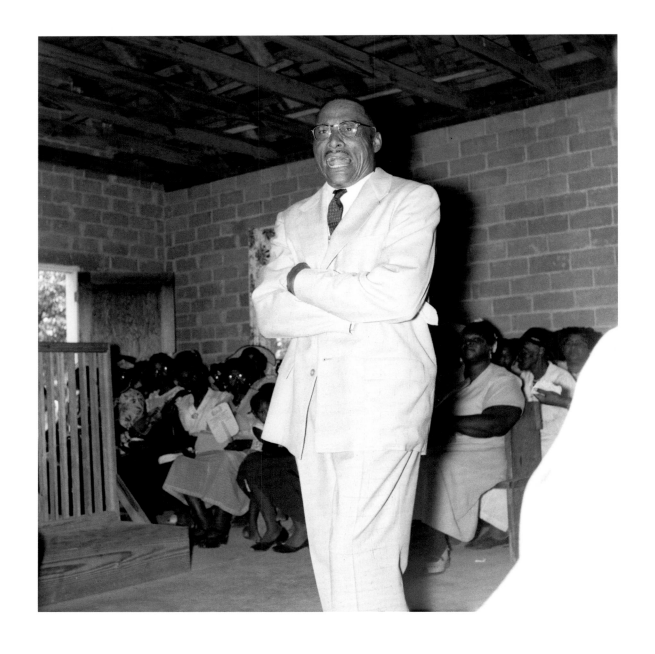

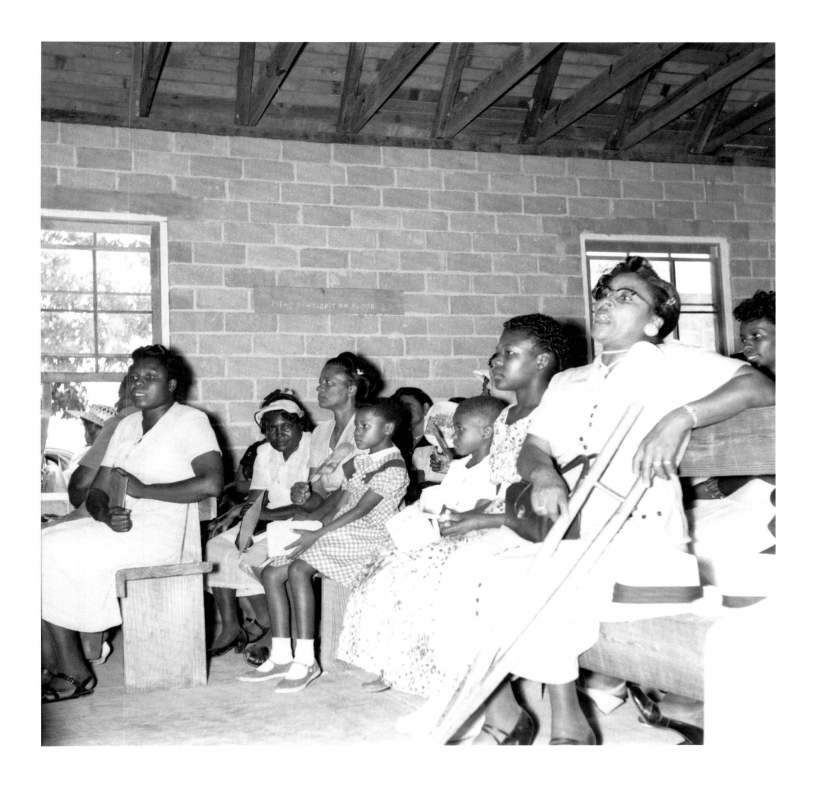

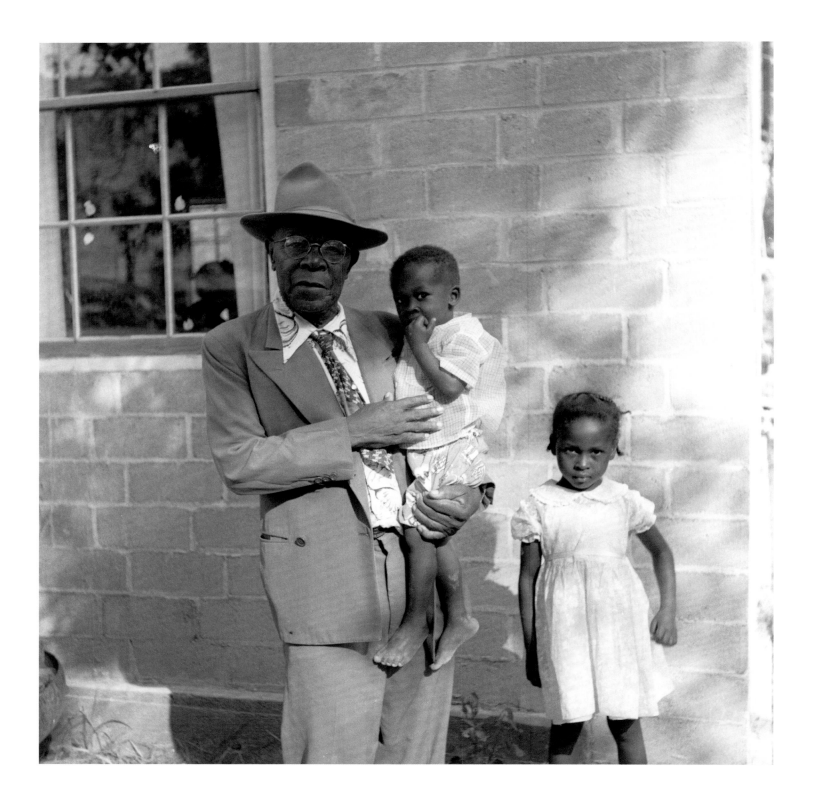

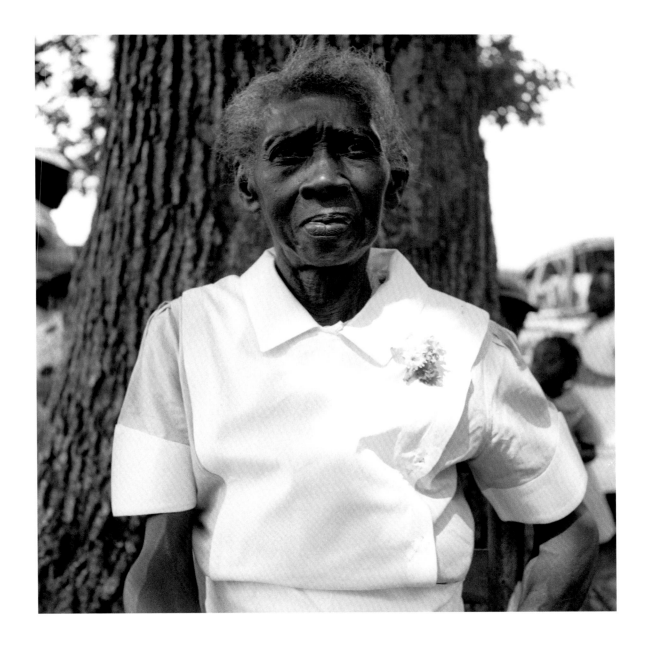

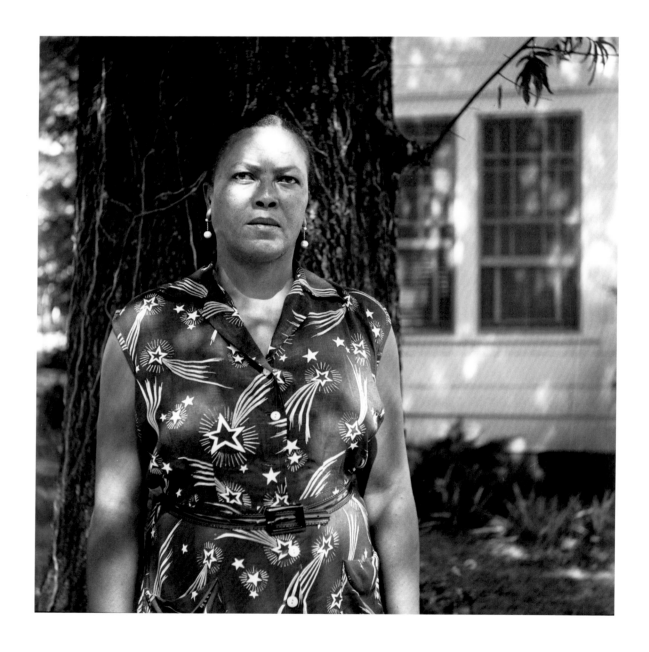

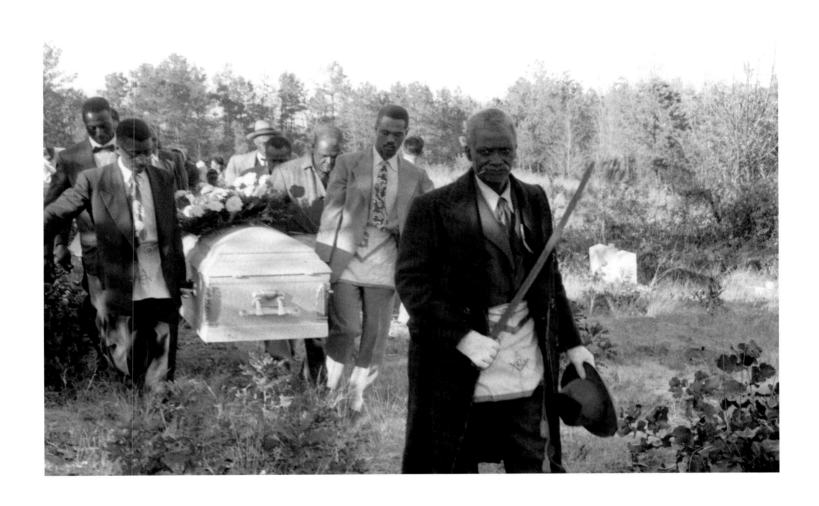

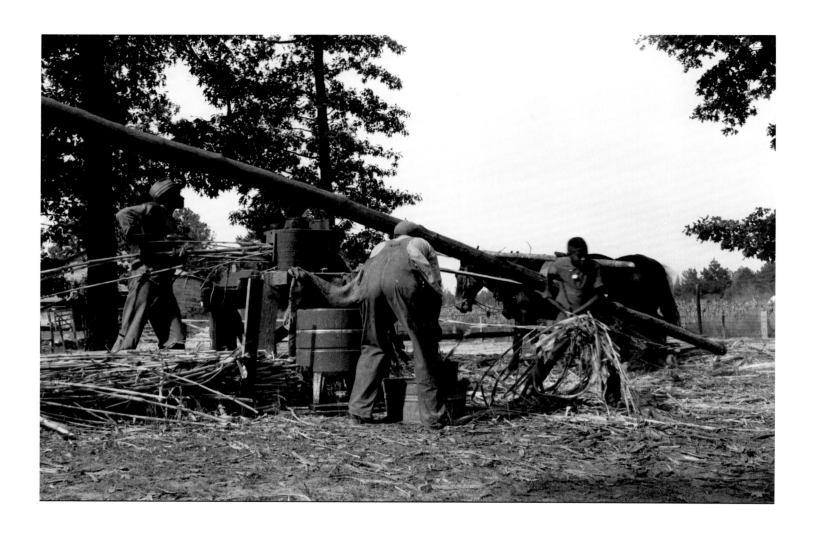

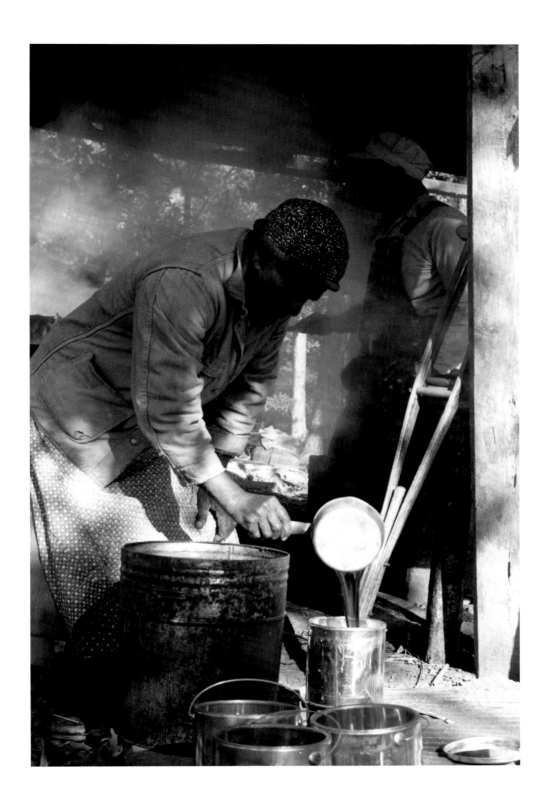

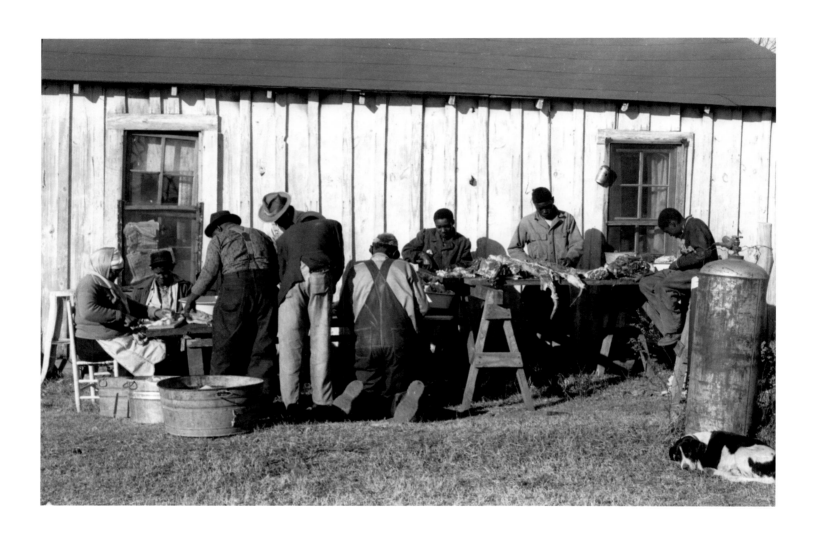

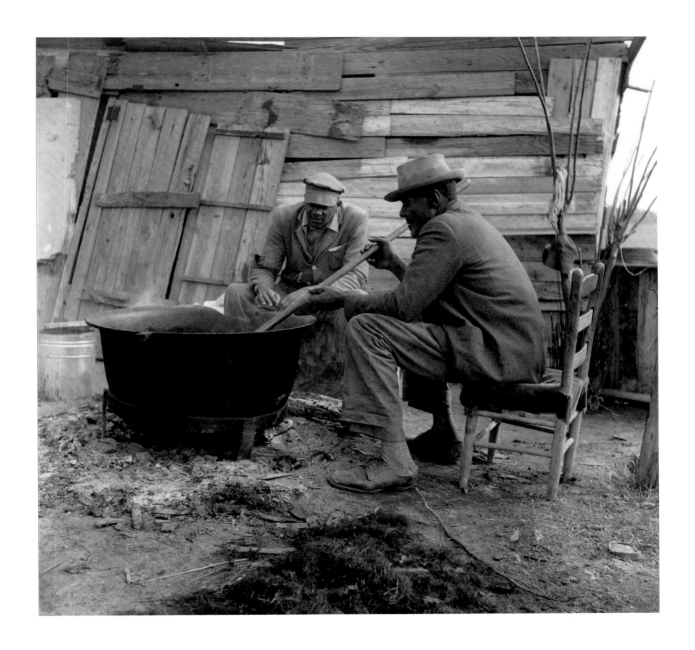

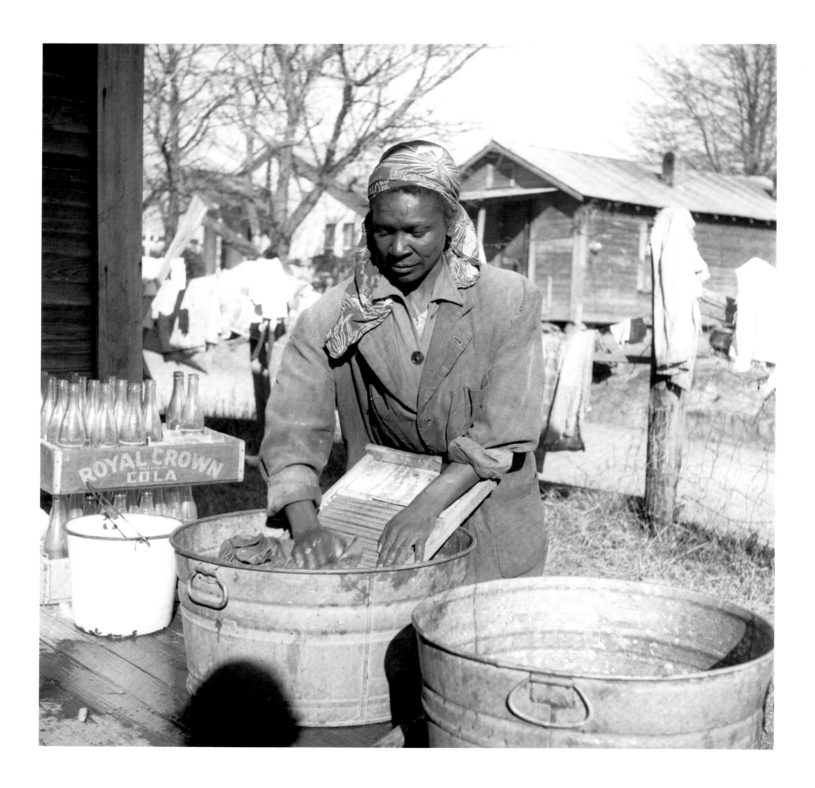

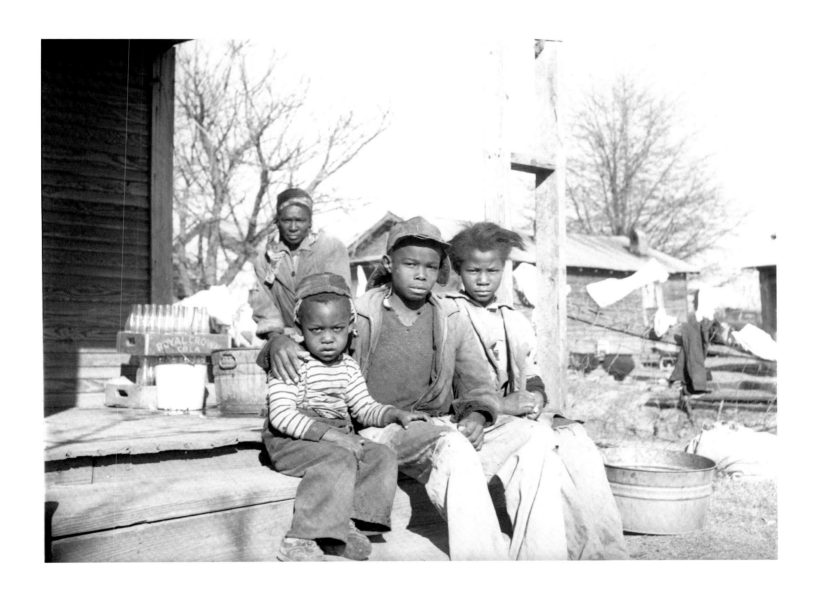

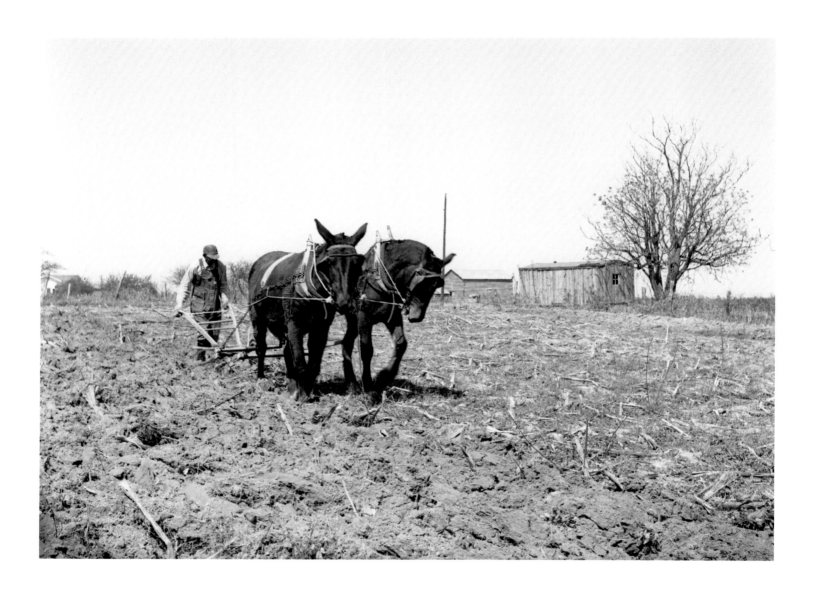

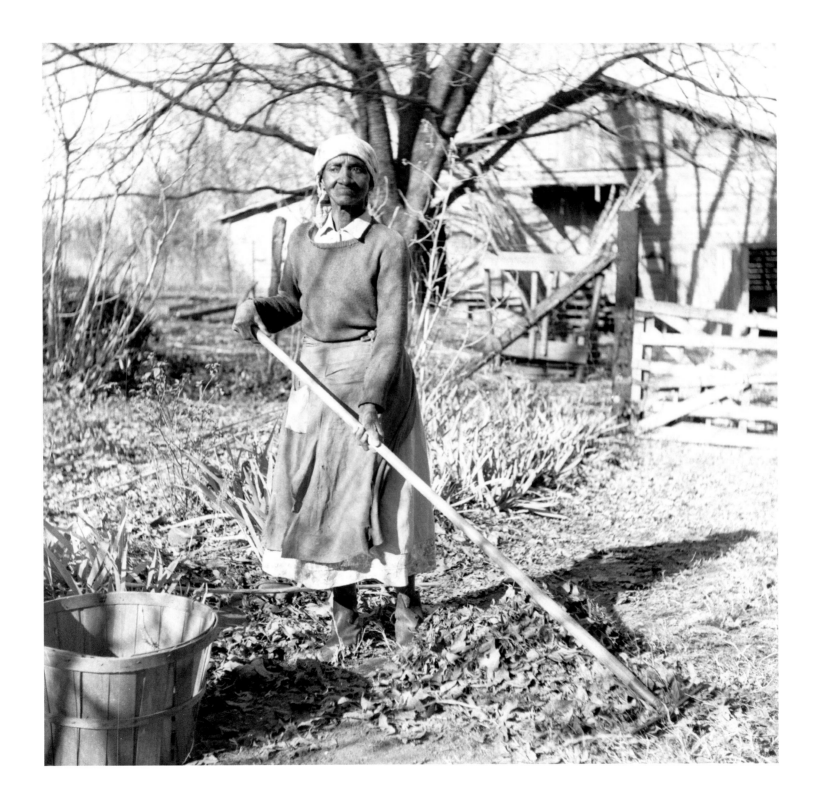

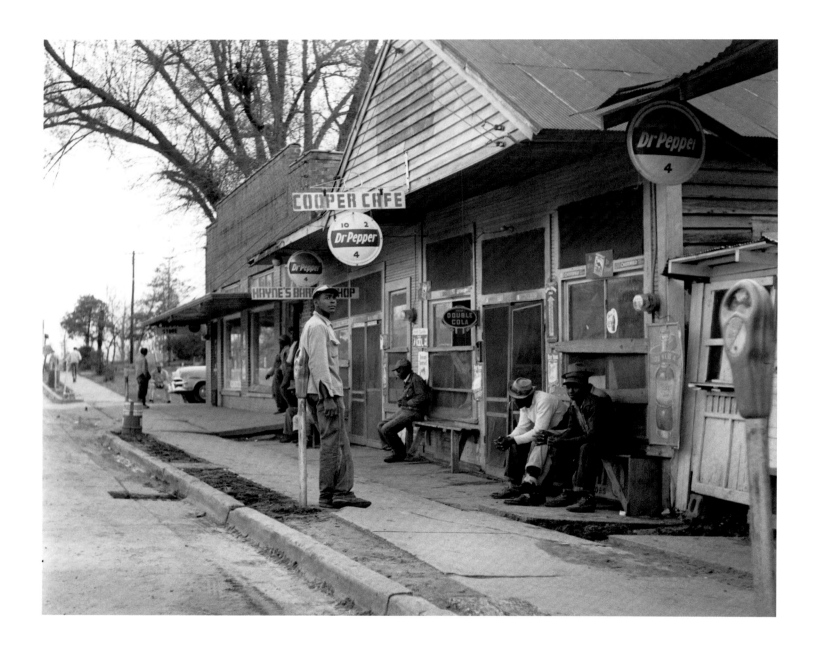

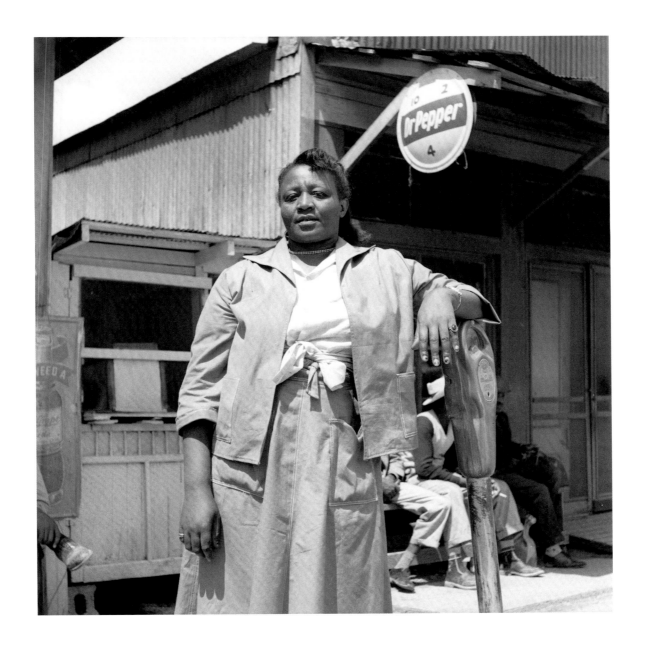

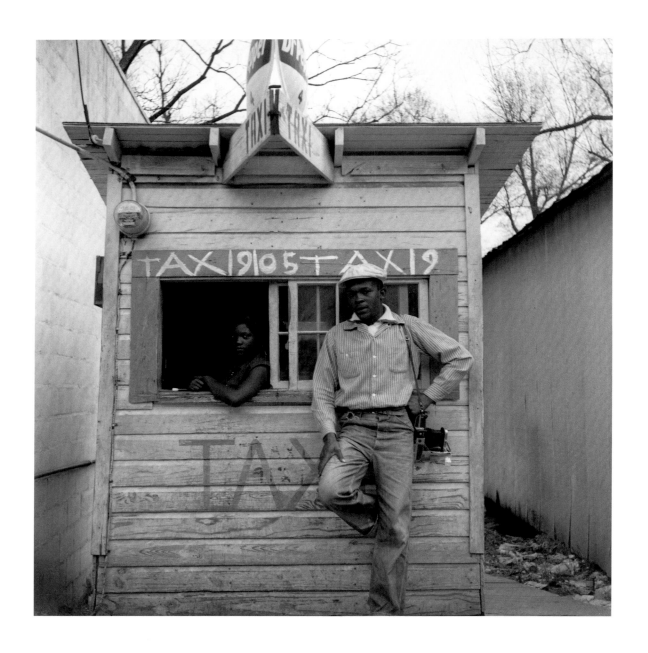

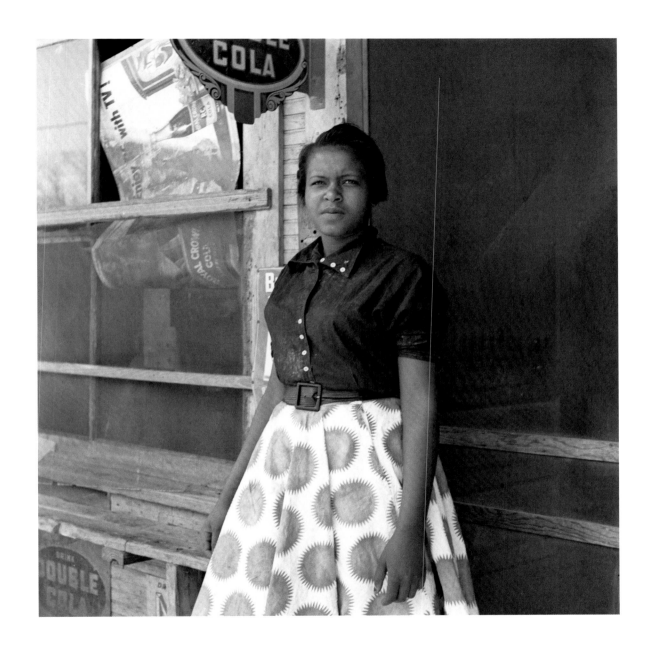

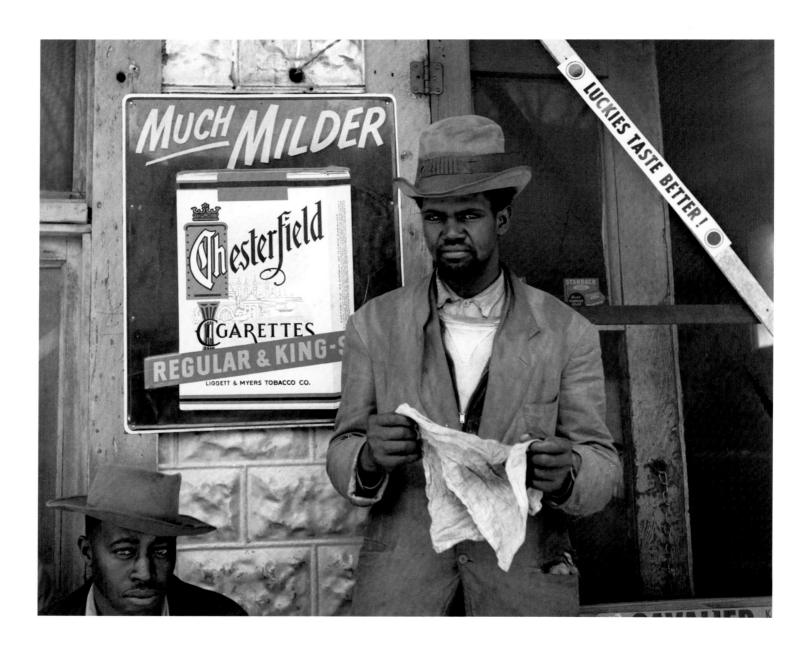

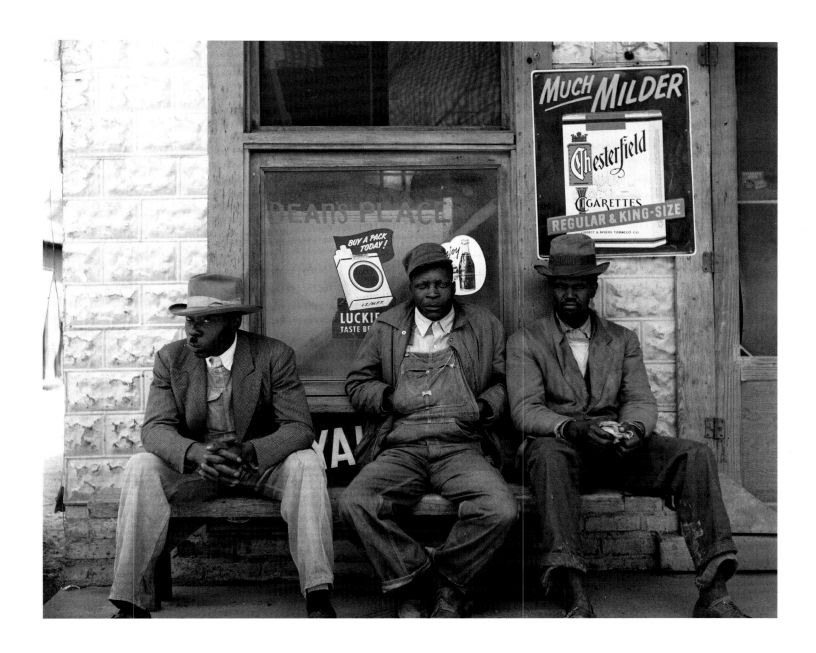

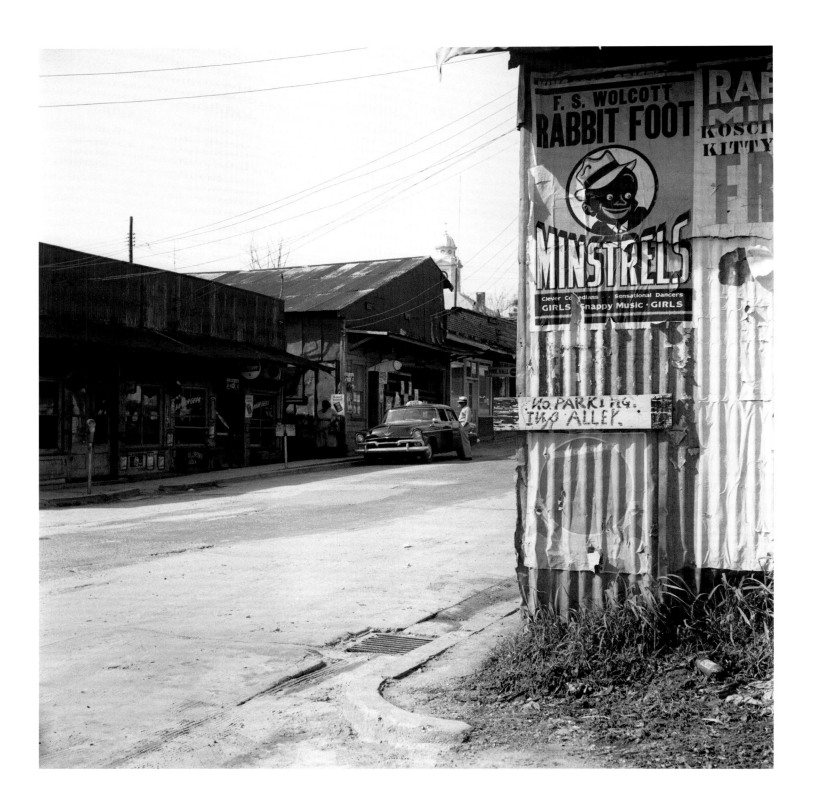

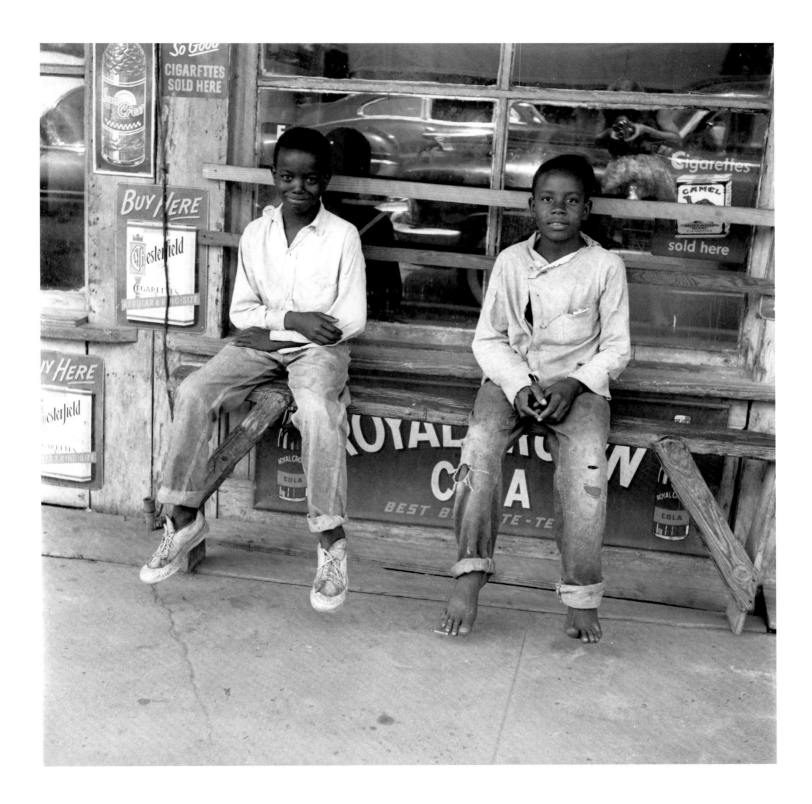

90

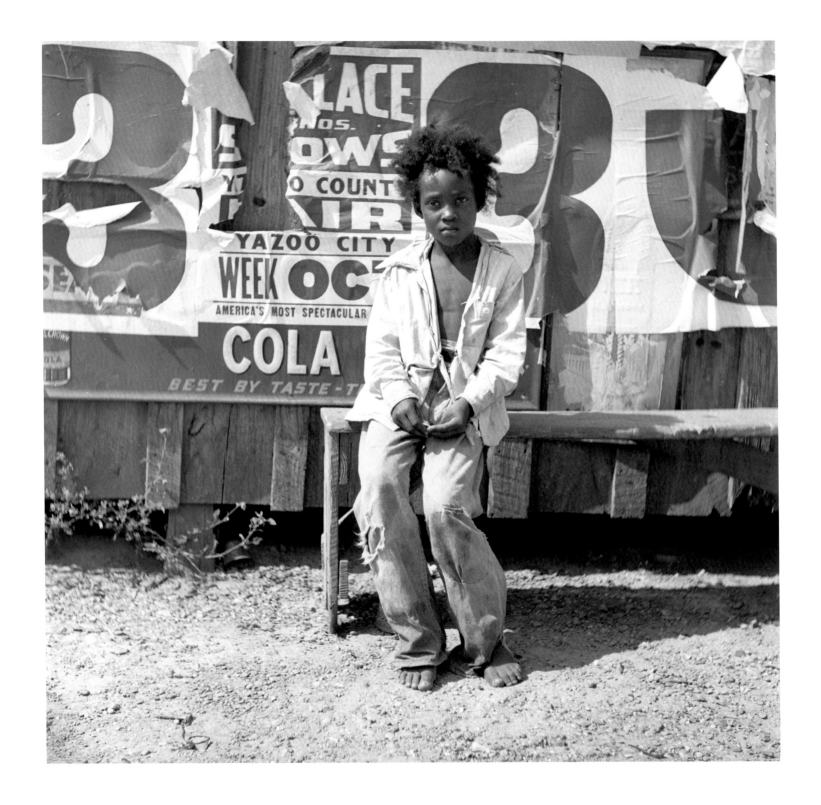

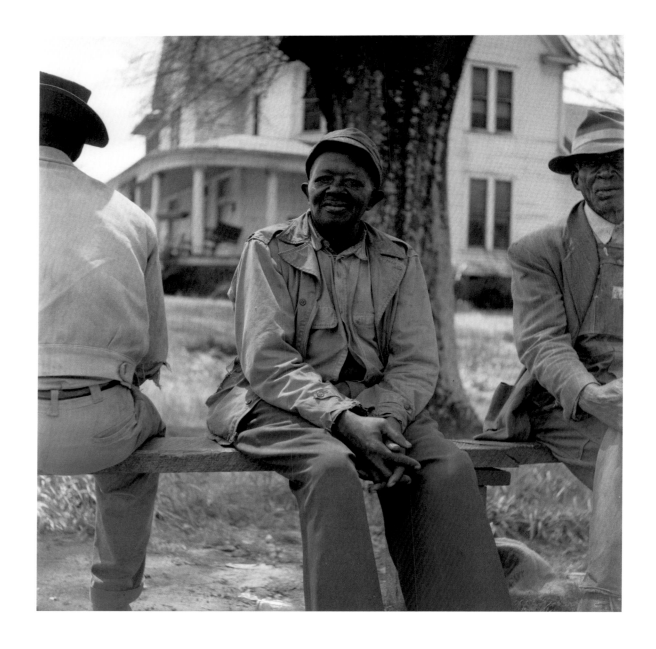

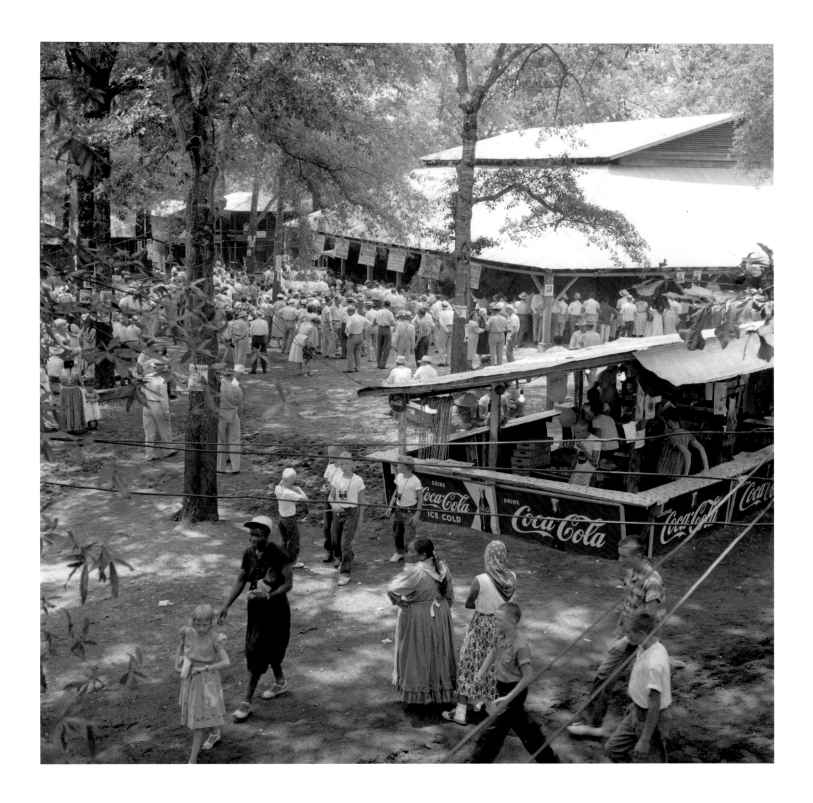

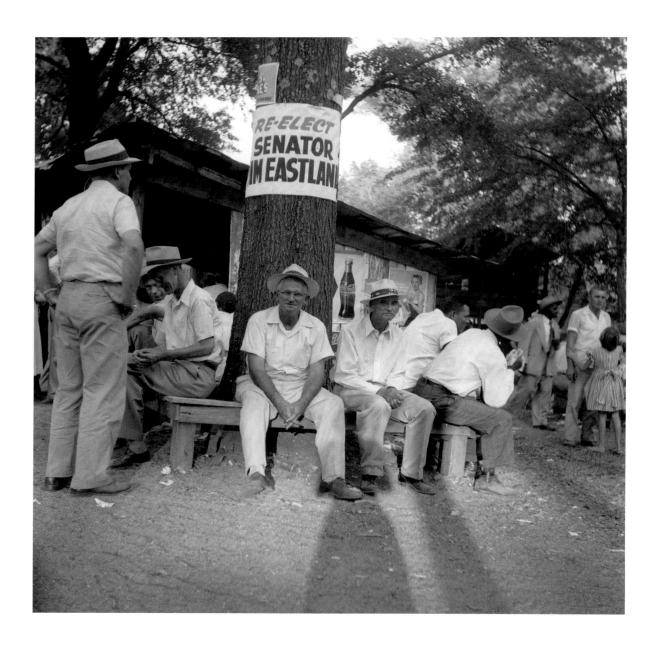

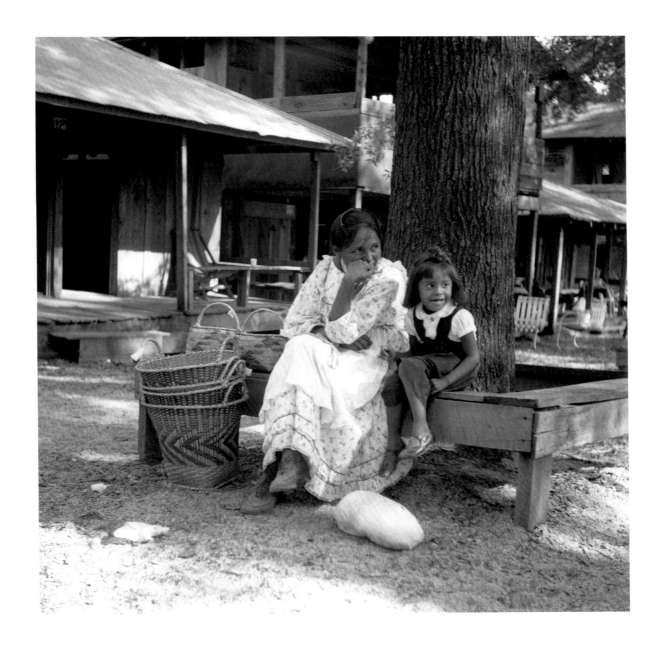

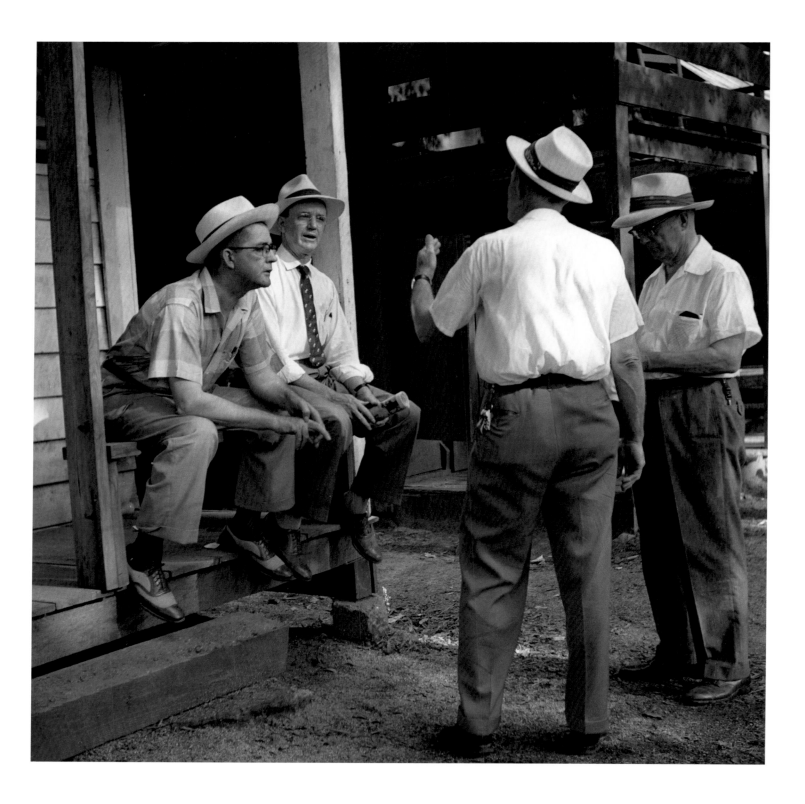

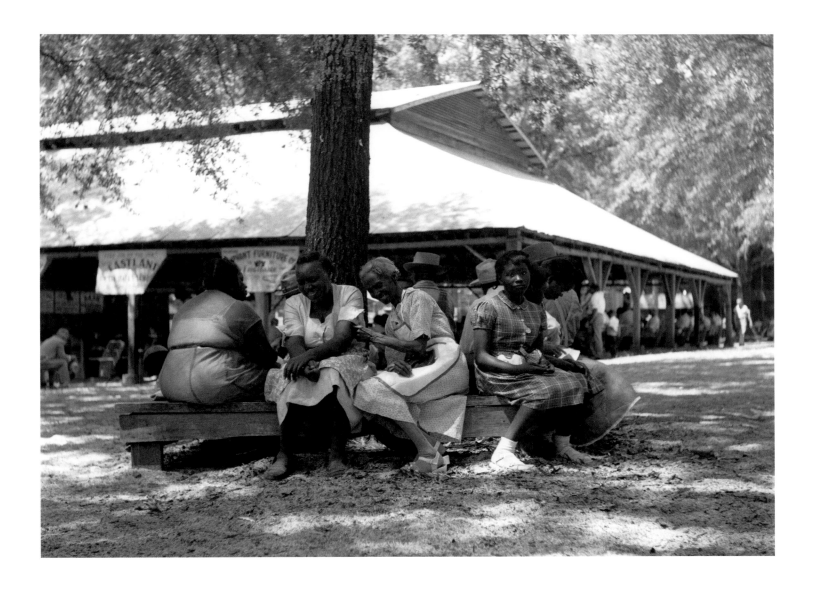

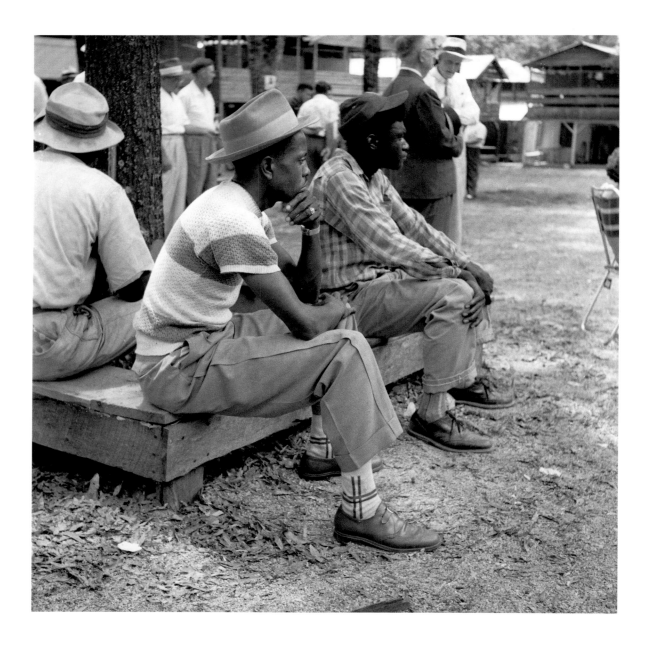

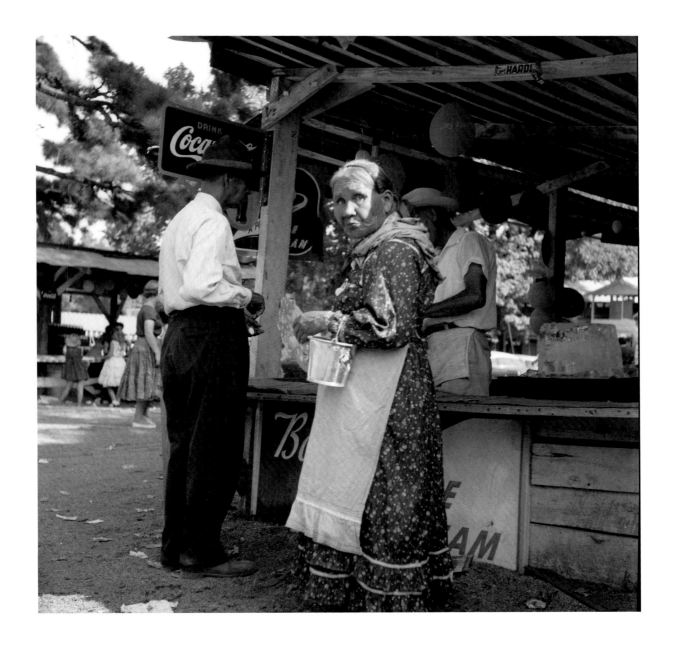

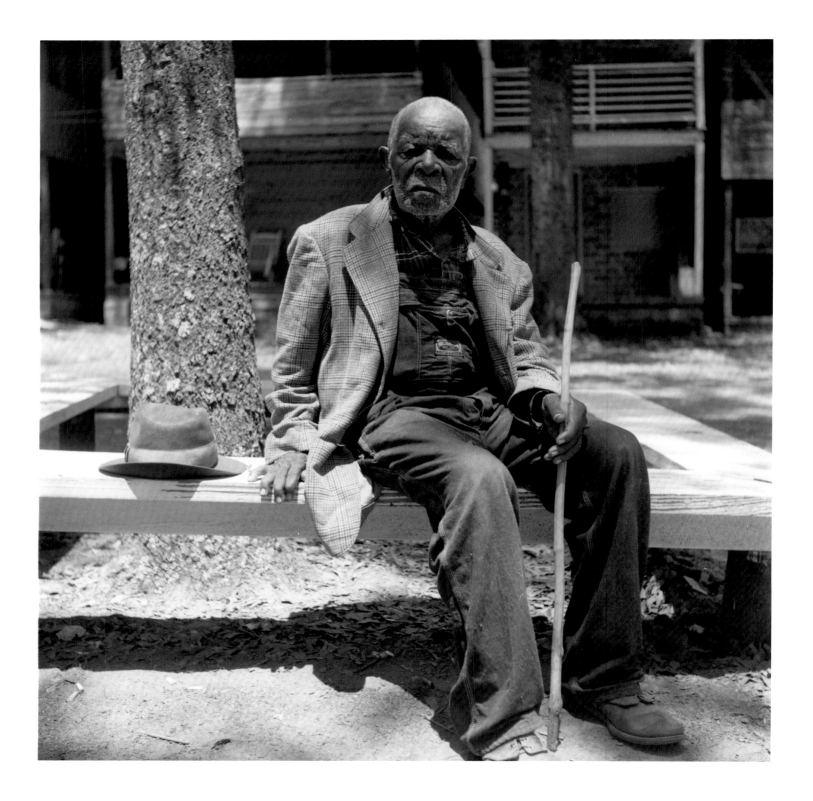

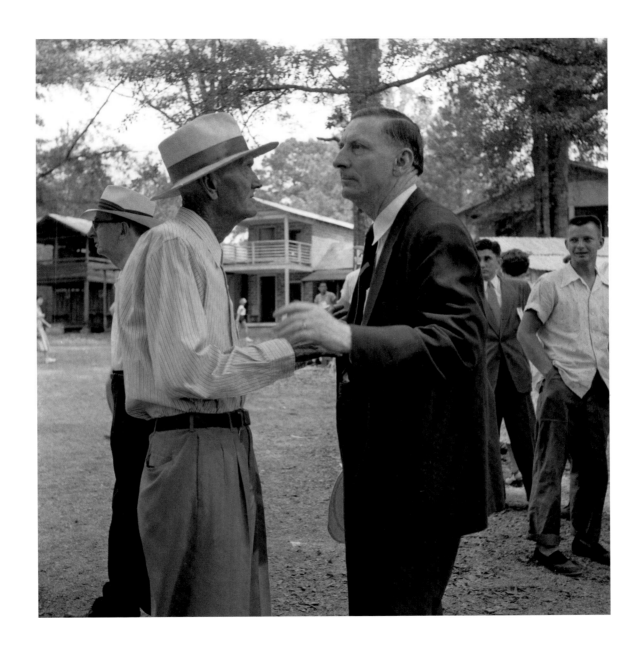

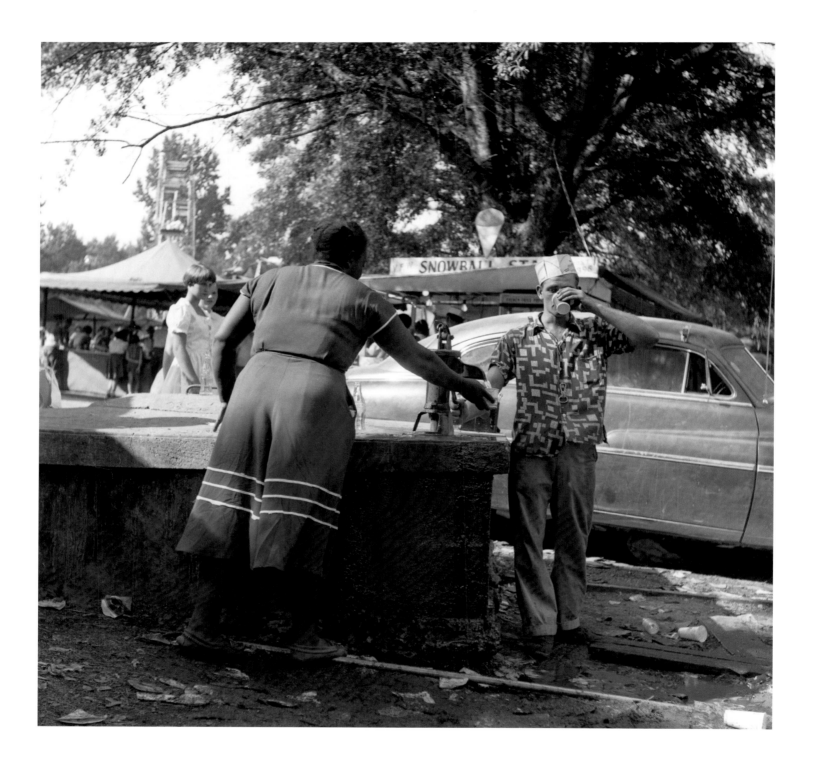

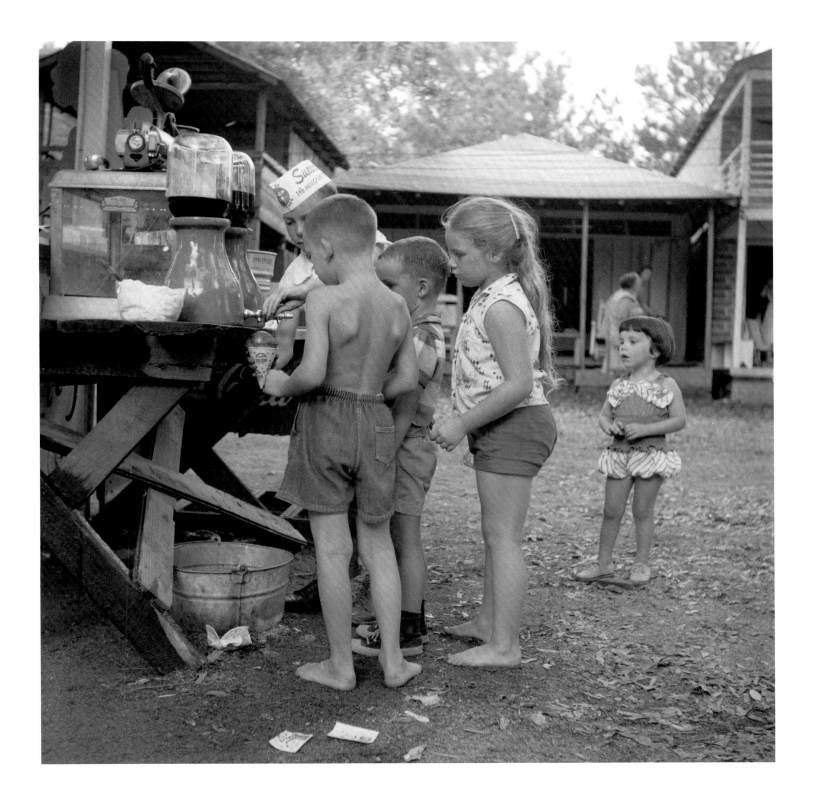

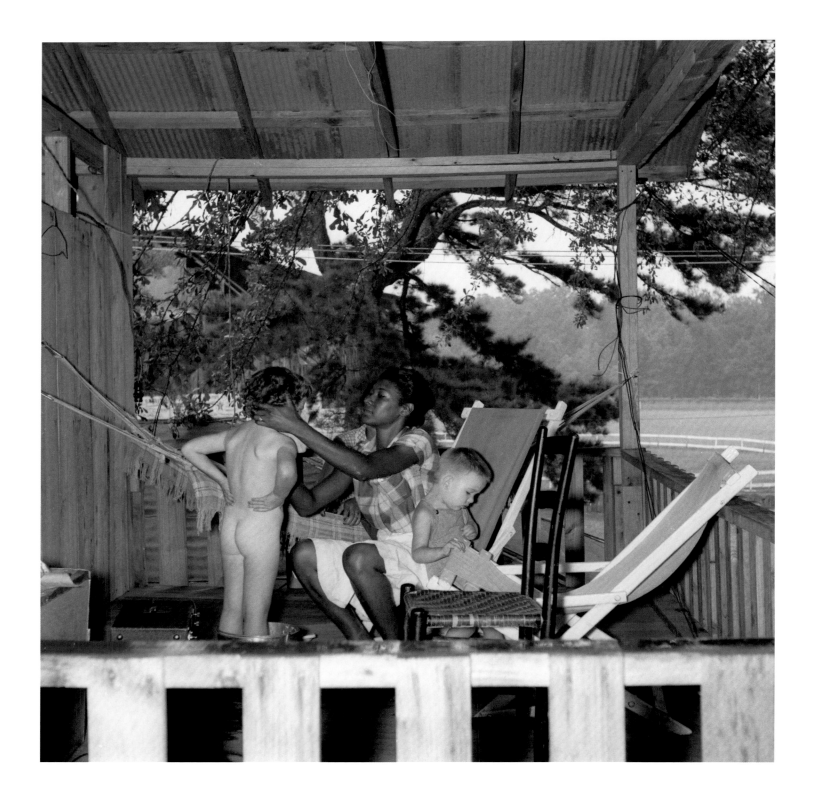

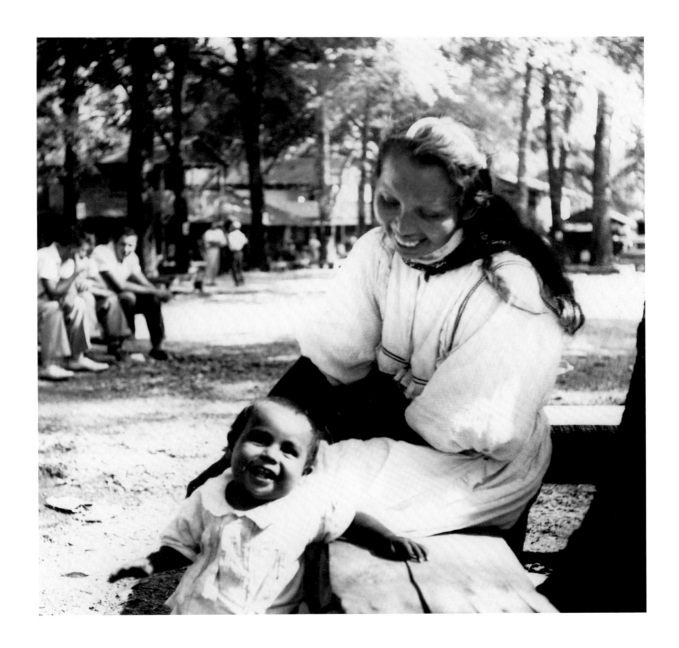

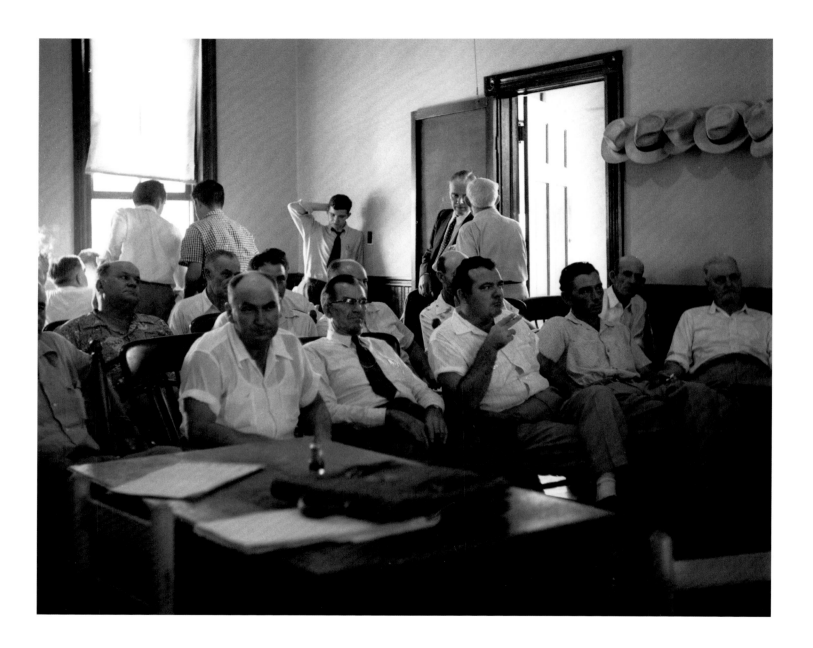

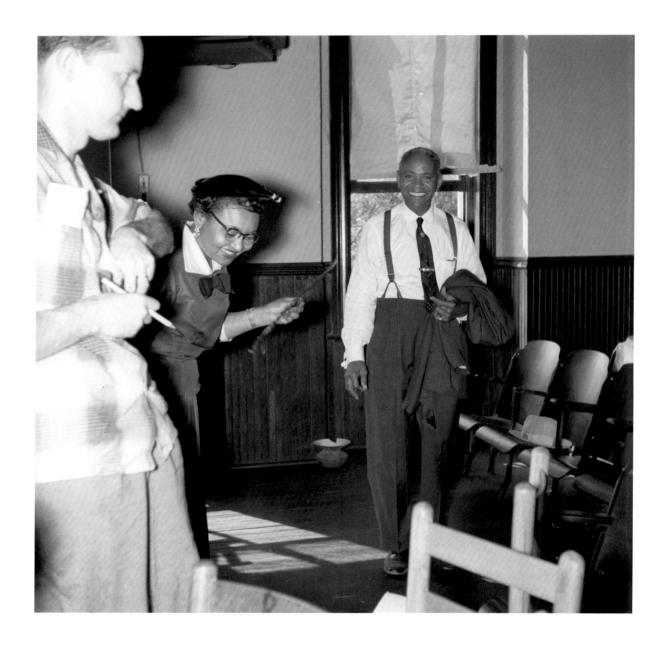

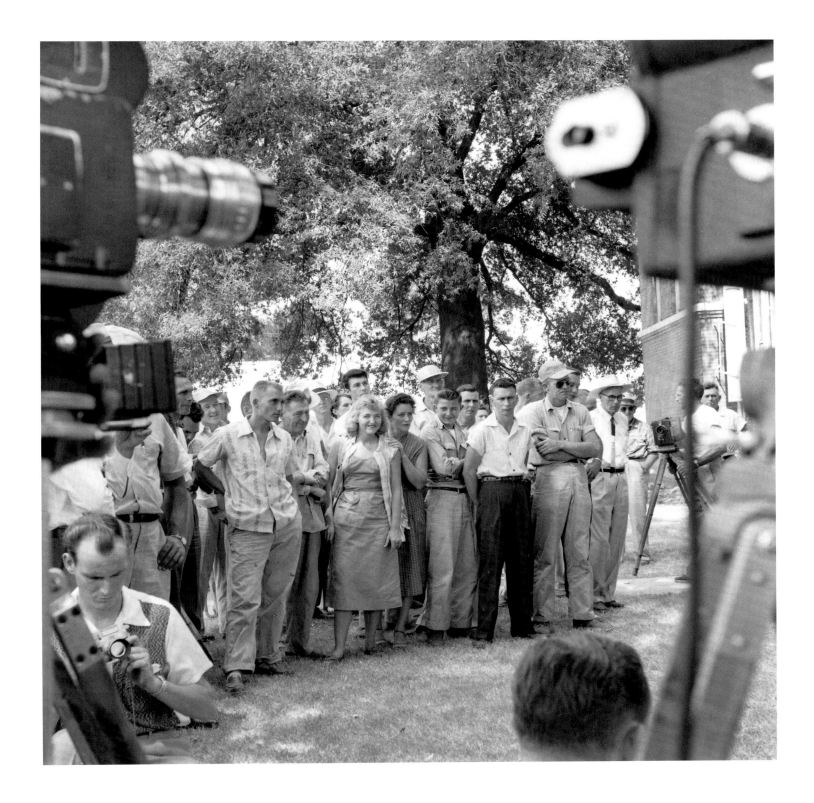

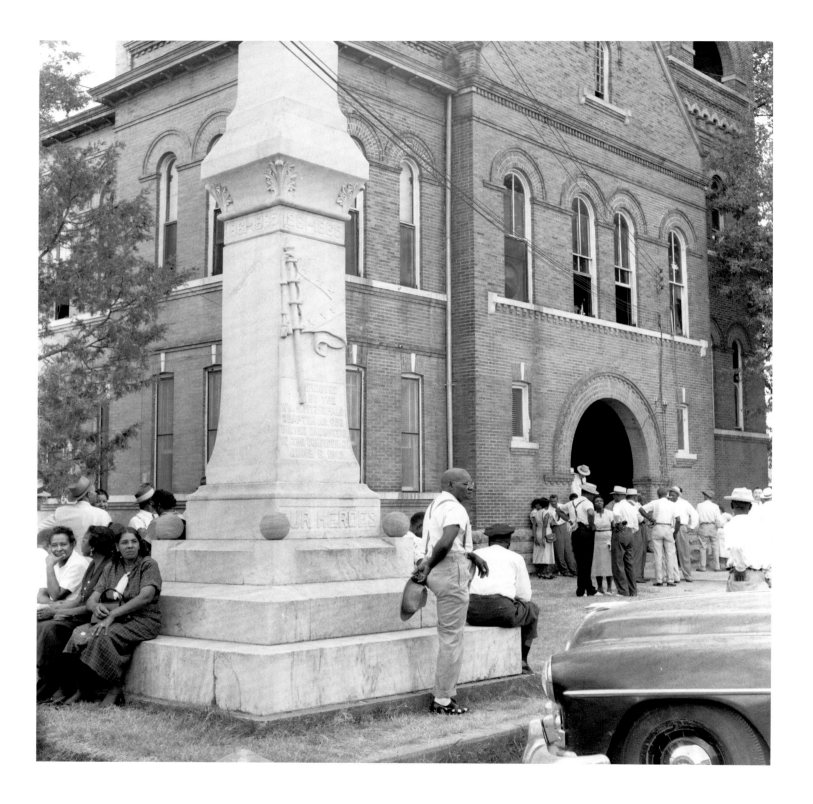

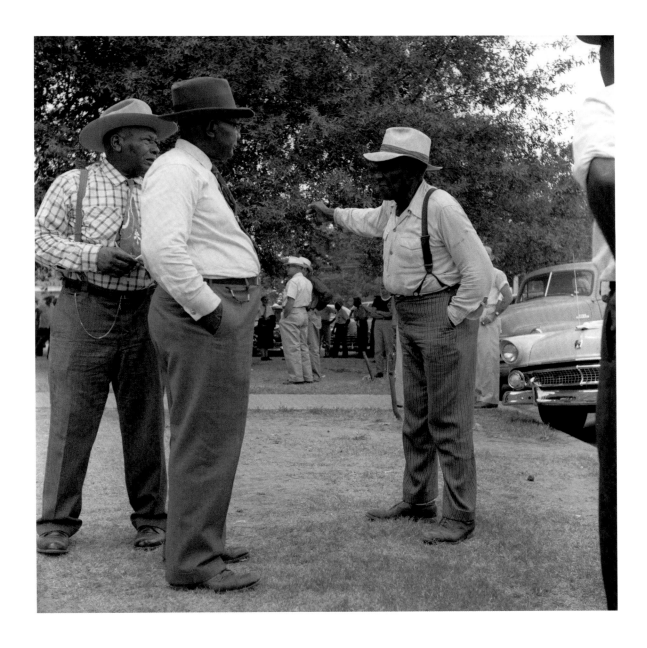

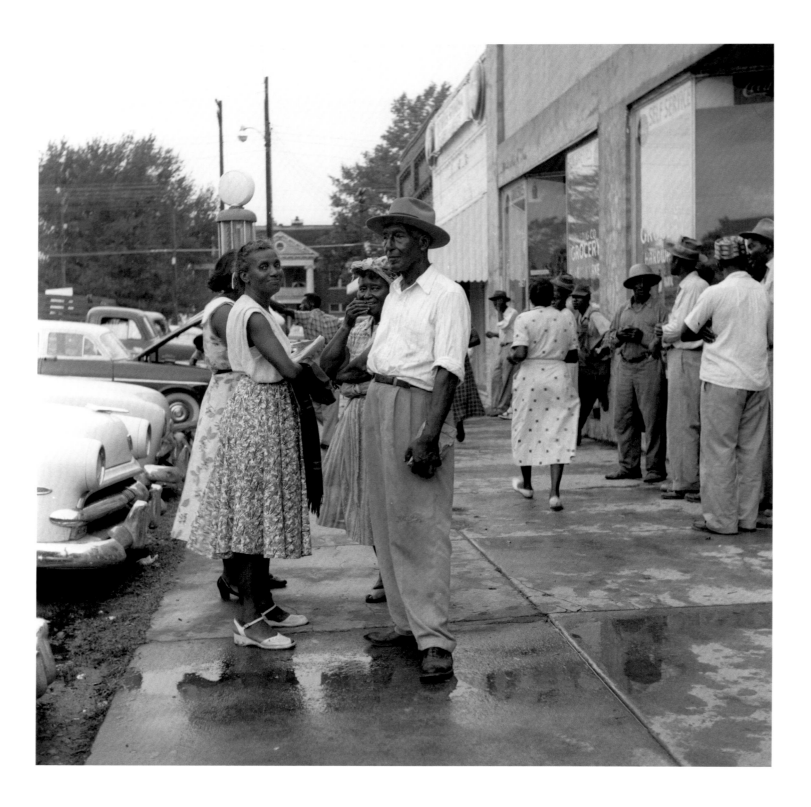

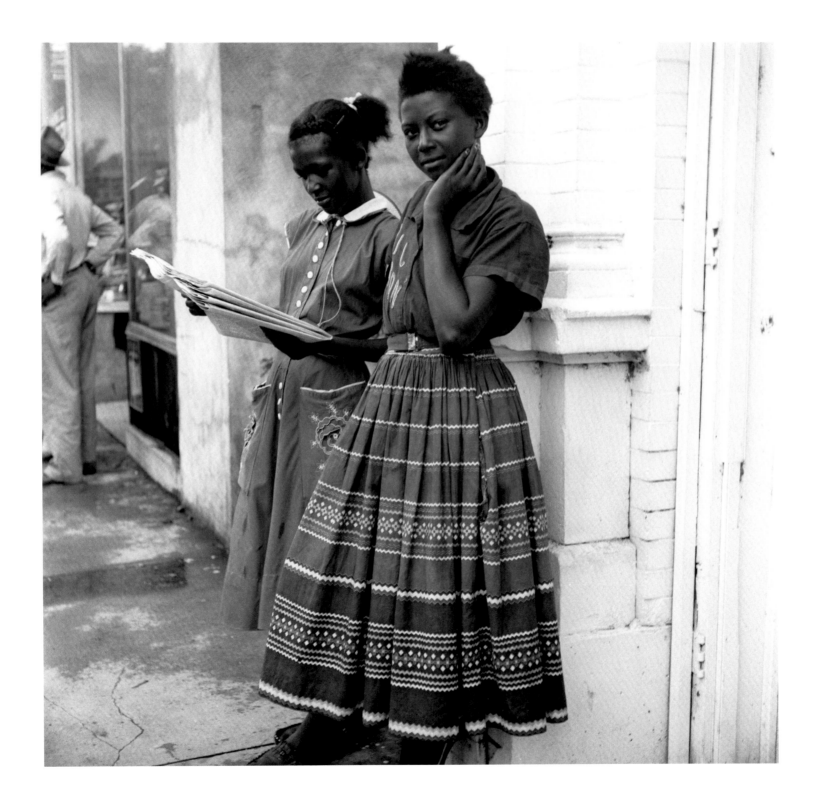

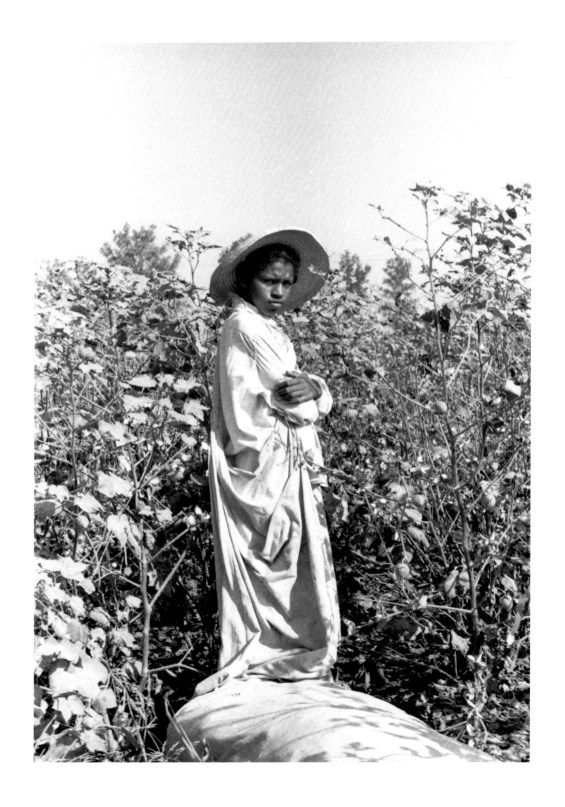

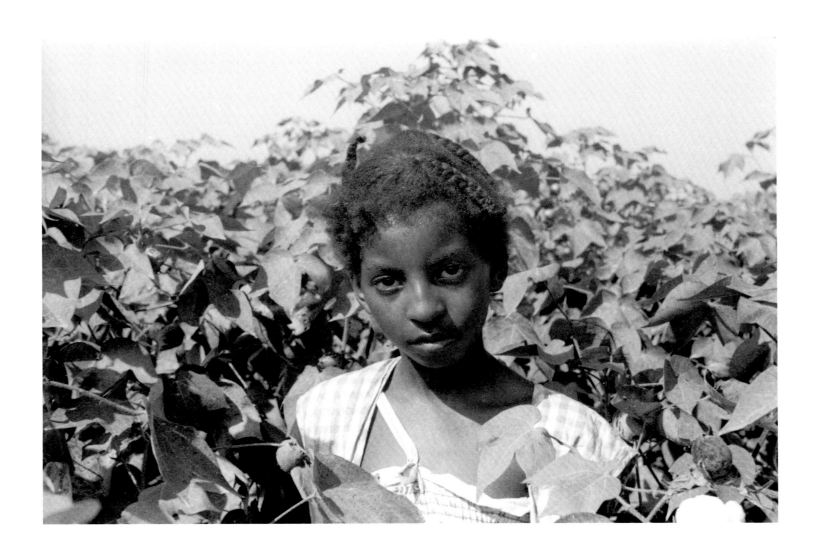

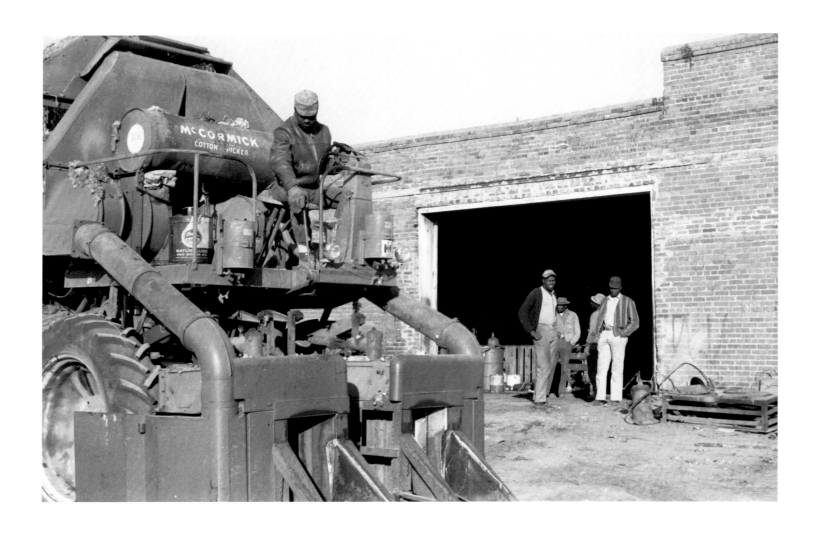

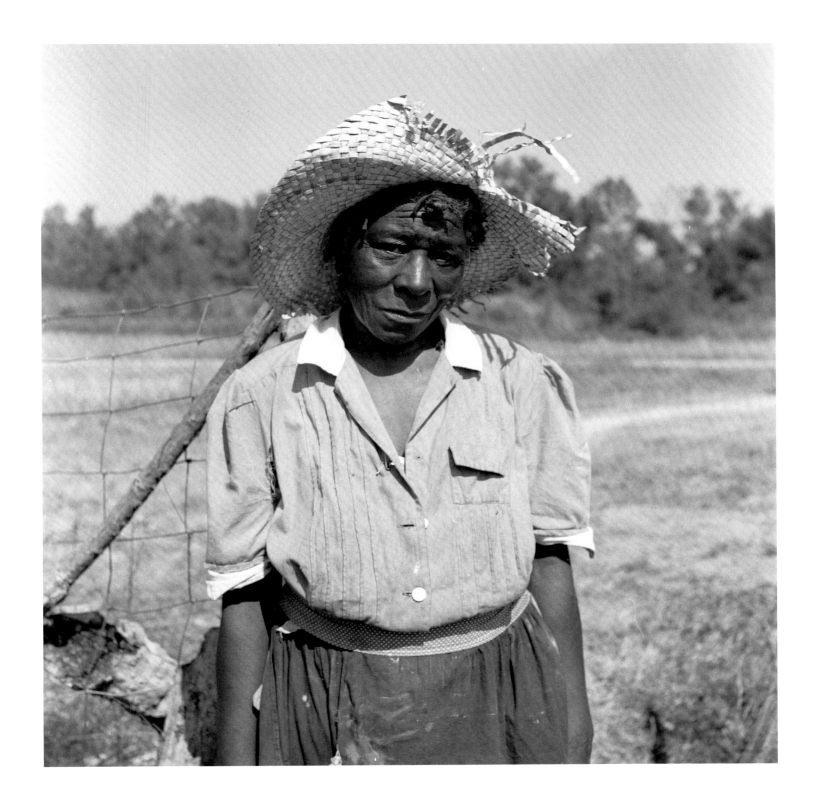

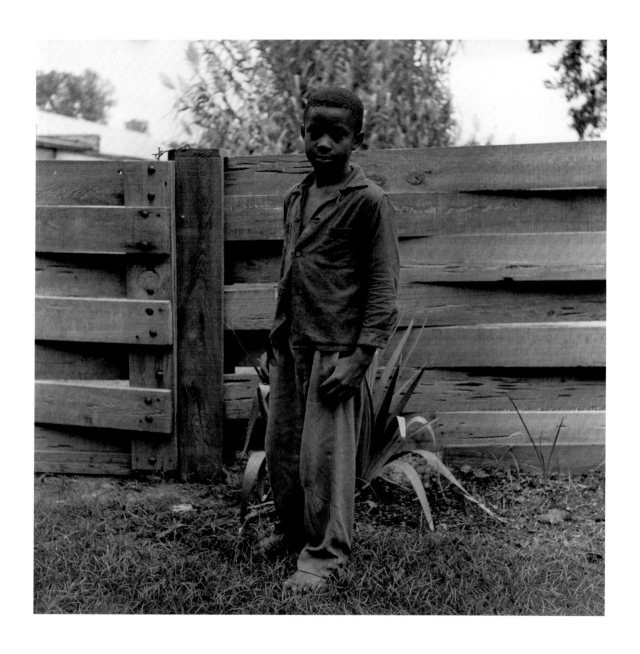

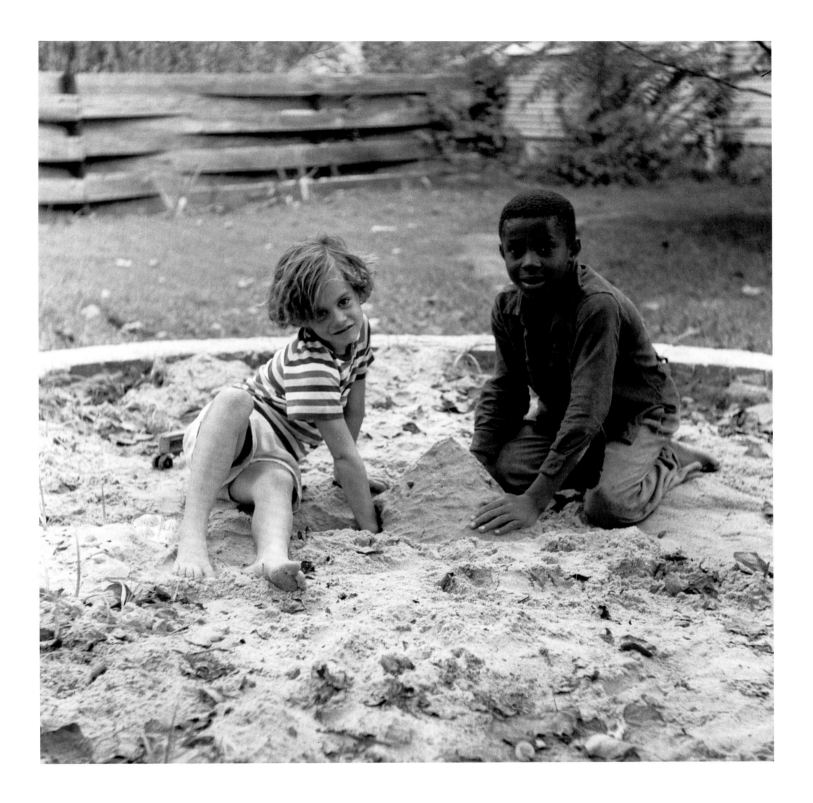

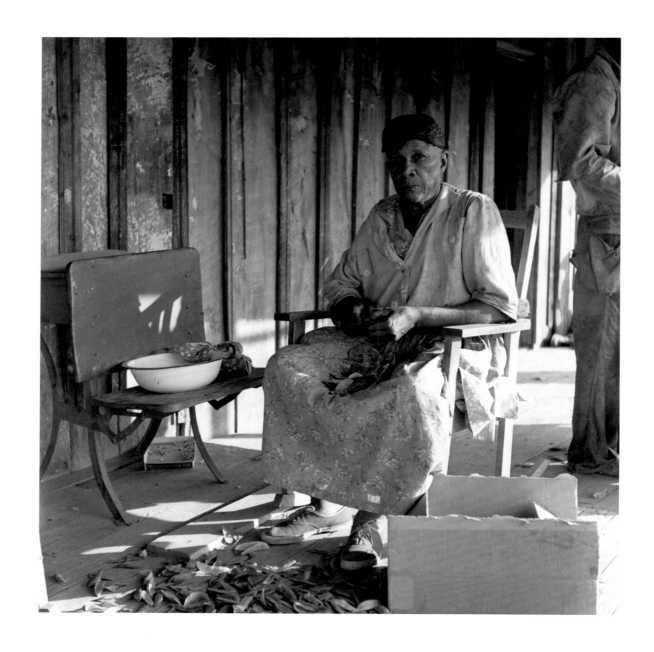

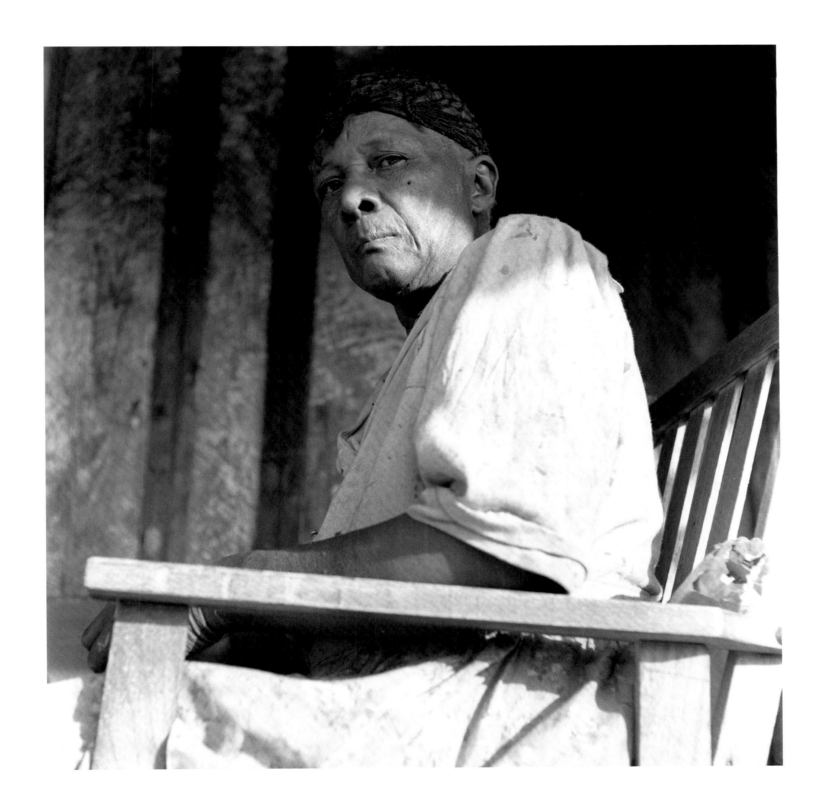

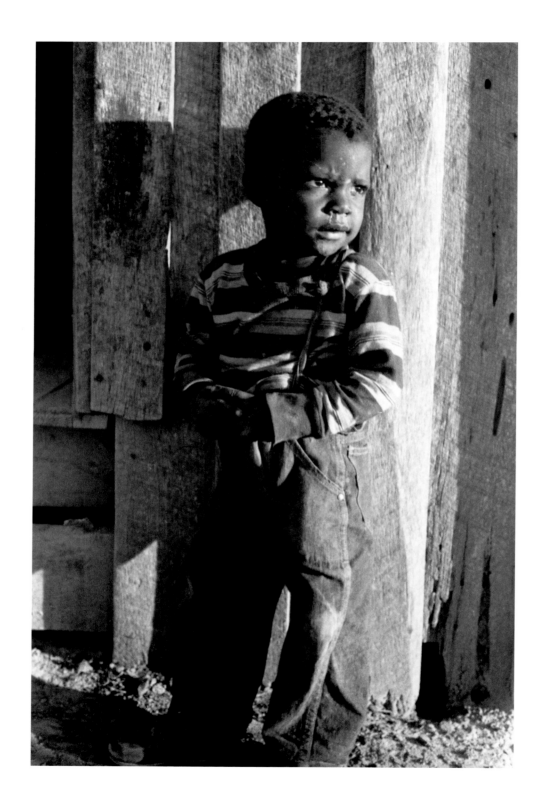

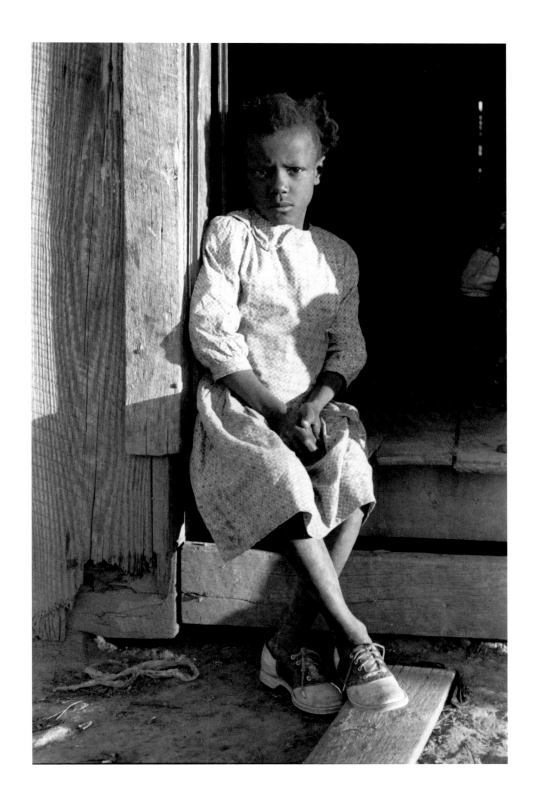

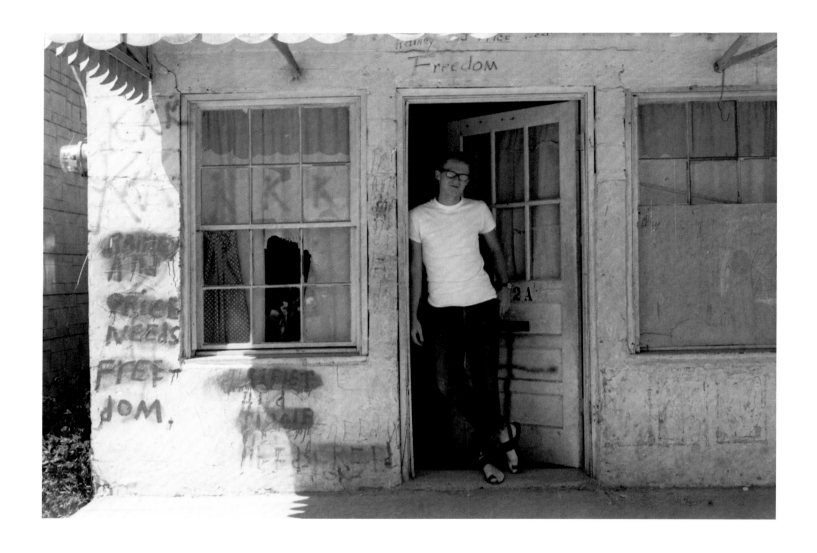

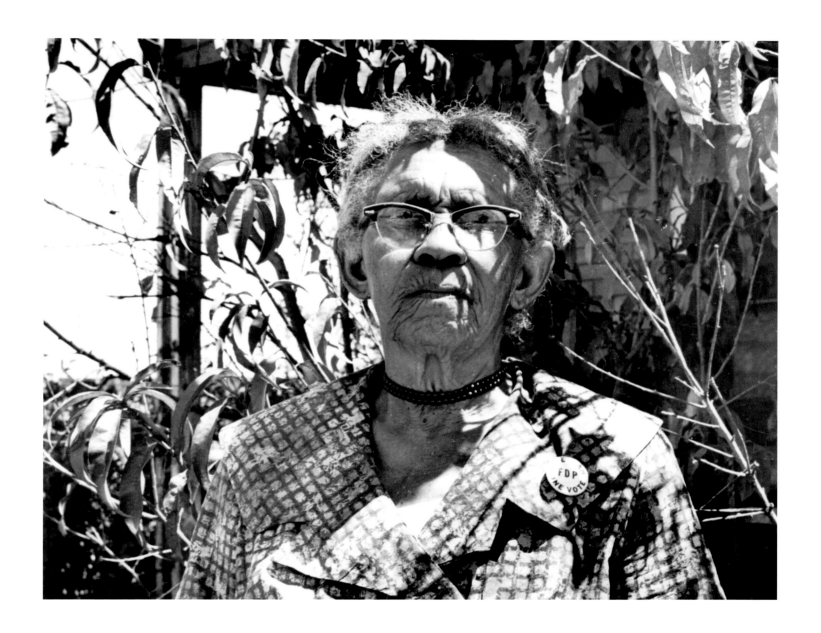

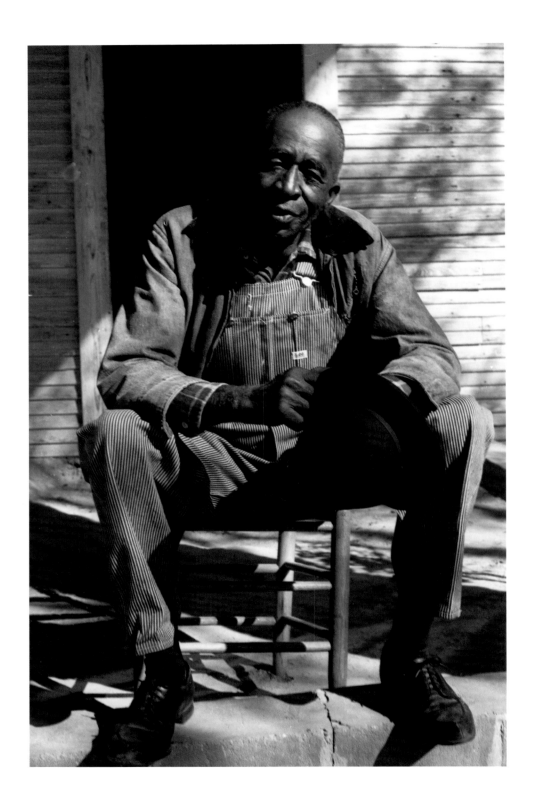

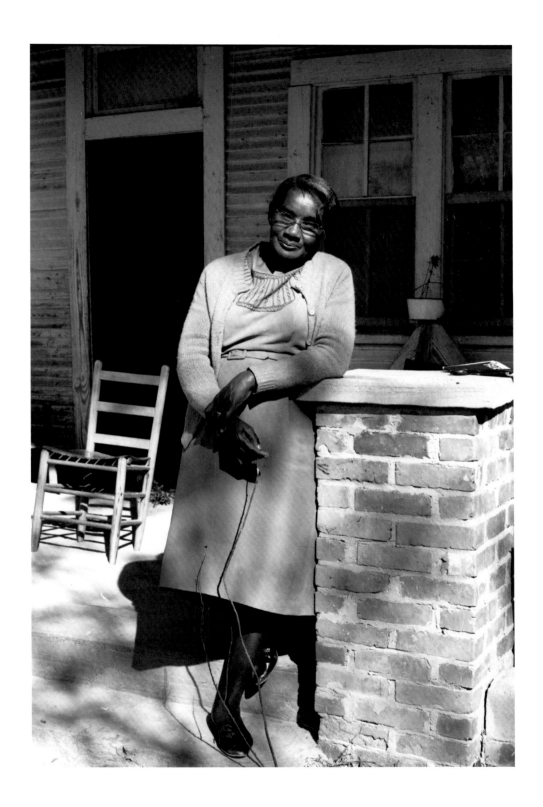

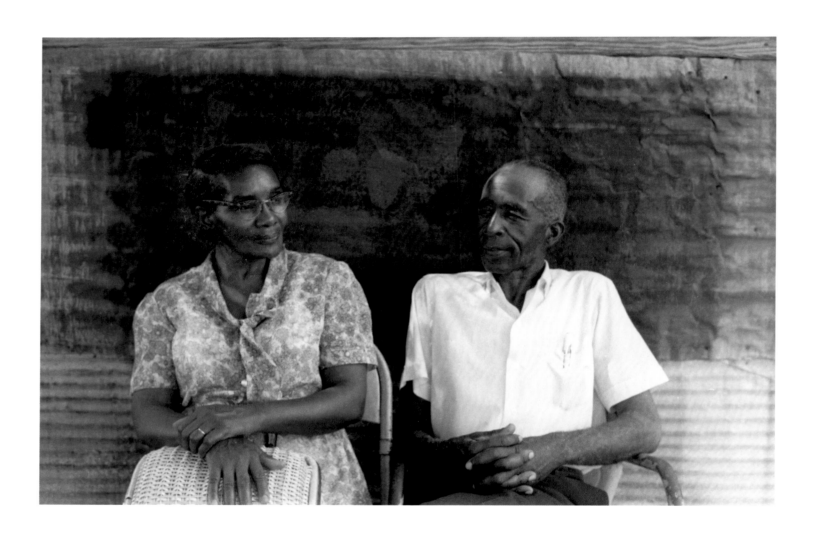

NOTES

1. Florence Mars (with the assistance of Lynn Eden), *Witness in Philadelphia* (Baton Rouge: Louisiana State University Press, 1977), p. 59.

2. The best account of the Philadelphia murders is Seth Cagin and Philip Dray, *We Are Not Afraid*: *The Story of Goodman, Schwerner, and Chaney, and the Civil Rights Campaign for Mississippi,* revised ed. (New York: Nation Books, 2006). See also William Bradford Huie, *Three Lives for Mississippi* (Jackson: University Press of Mississippi, 2000, orig. pub. 1965).

3. Interview with Charles E. Cobb Jr., October 21, 1996, Center for Oral History and Cultural Heritage, University of Southern Mississippi, p. 16. On the origins of the 1964 Freedom Summer project, see John Dittmer, *Local People*: *The Struggle for Civil Rights in Mississippi* (Champaign: University of Illinois Press, 1994), and Charles M. Payne, *I've Got the Light of Freedom*: *The Organizing Tradition and the Mississippi Freedom Struggle* (Berkeley: University of California Press, 1995).

4. *Witness in Philadelphia,* pp. viii, 84–119. See also notes from Mars's interview of FBI agent Joseph Sullivan, August, 1968, Florence Mars Papers, Mississippi State University Archives, box 1.

5. *Witness in Philadelphia,* p. 87.

6. *Neshoba Democrat,* January 26, 1967. Trial transcripts for the case, *United States v. Price,* et al., are available at https://www.justice.gov/crt/trial-transcripts-caseunited-states-v-price-et-al-also-known-mississippi-burning-incident-1967.

7. Florence Mars Papers, Mississippi Department of Archives and History, Journal, Summer/Fall 1965, box 1, p. 13.

8. Interview with Florence Mars, January 5, 1978, Center for Oral History and Cultural Heritage, University of Southern Mississippi, p. 16.

9. Florence Mars, *The Bell Returns to Mt. Zion* (Philadelphia, MS: Stribling Printing, 1996), pp. 15, 24; Mars, *Witness in Philadelphia,* pp. 21, 38.

10. Interview with Stanley Dearman and Florence Mars by James Campbell, July 26, 2003. See also *The Bell Returns to Mt. Zion,* pp. 11–19, and *Witness in Philadelphia,* pp. 8–21.

11. *The Bell Returns to Mt. Zion,* p. 15; *Witness in Philadelphia,* p. 36. See also Stanley Dearman, "Florence Mars," in Joan H. Sadoff (ed.), *Pieces from the Past*: *Voices of Heroic Women in Civil Rights* (n.p., Tasora, 2011), pp. 35–47.

12. *The Bell Returns to Mt. Zion,* pp. 21–22.

13. Ibid., pp. 5, 21–22, 30, 54.

14. *Witness in Philadelphia,* pp. 37–39.

15. *The Bell Returns to Mt. Zion,* pp. 27–28. See also Vernon Wharton, *The Negro in Mississippi, 1865–1890* (Chapel Hill: University of North Carolina Press, 1947).

16. Interviews with Betty Bobo Pearson by James Campbell, August 26, 2015, and February 25, 2018. See also Sally Palmer Thomason with Jean Carter Fisher, *Delta Rainbow*: *The Irrepressible Betty Bobo Pearson* (Jackson: University Press of Mississippi, 2016), pp. 41–42. Cf. Mars's accounts in *Witness in Philadelphia,* pp. 29–30, and *The Bell Returns to Mt. Zion,* p. 29.

17. Lillian Smith, *Killers of the Dream* (New York: W. W. Norton, 1944). (The quotation comes from Smith's foreword to the 1961 revised edition.) See also Smith, *Strange Fruit: A Novel* (New York: Reynal and Hitchcock, 1944).

18. Quoted in *The Bell Returns to Mt. Zion,* p. 41. Conway's original letter is deposited in the Mars papers at Mississippi State University. On *The Outsider,* see *Bohemian New Orleans: The Story of the Outsider and Loujon Press* (Jackson: University Press of Mississippi, 2016).

19. Crawford provided the album cover photos for Riverside Records' germinal 1961 series, *New Orleans: The Living Legends,* while Mars provided many of the smaller jacket photos. On Crawford's work as a photographer, see Olivia Lahs-Gonzales and John H. Lawrence, eds., *Ralston Crawford and Jazz* (St. Louis: Virginia, 2011); Keith Davis, ed., *Ralston Crawford: Abstracting the Vernacular* (New York: Laurence Miller Gallery, 1995); Edith A. Tonelli, *Ralston Crawford: Photographs/Art and Process* (College Park: University of Maryland Art Gallery, 1983); and Ralston Crawford, *Music in the Street: Photographs of New Orleans* (New Orleans: Historic New Orleans Collection, 1983).

20. See Ethan Michaeli, *The Defender: How the Legendary Black Newspaper Changed America* (New York: Houghton Mifflin Harcourt, 2016.) On the Trumbull Park riots, see Arnold Hirsch, *Making the Second Ghetto: Race and Housing in Chicago, 1940–1960* (Chicago: University of Chicago Press, 1983), pp. 68–99.

21. *The Bell Returns to Mt. Zion,* pp. 44–45.

22. Quoted in Elizabeth Partridge, *Dorothea Lange: Grab a Hunk of Lightning* (San Francisco: Chronicle Books, 2013), p. 76. On the FSA photographers, see Jean Back et al., *The Bitter Years: Edward Steichen and the Farm Security Administration* (London: Thames and Hudson, 2012); Stu Cohen, *The Likes of Us: America in the Eyes of the Farm Security Administration* (Boston: David R. Godine, 2008); and Lincoln Kirstein and Walker Evans, *Walker Evans: American Photographs: Seventy-Fifth Anniversary Edition* (New York: Museum of Modern Art, 2012).

23. Reynolds Price, ed. *Eudora Welty Photographs* (Jackson: University Press of Mississippi, 1989).

24. See Sandra S. Phillips, *Exposed: Voyeurism, Surveillance, and the Camera Since 1870* (New Haven: Yale University Press, 2010). See also Walker Evans, *Many Are Called,* introduction by James Agee (Boston: Houghton Mifflin, 1966); Sarah Greenough, *Walker Evans: Subways and Streets* (Washington DC: Natl Gallery of Art, 1991); Deborah Martin Kao, Laura Katzman, and Jenna Webster, *Ben Shahn's New York: The Photography of Modern Times* (Cambridge: Harvard University Press, 2000); and Linda Gordon, *Dorothea Lange: A Life Beyond Limits* (New York: W. W. Norton, 2010), especially pp. 235–43.

25. *The Bell Returns to Mt. Zion,* pp. 51, 62.

26. Quoted in *Witness in Philadelphia,* p. 71. On the Citizens' Council, see Neil R. McMillen, *The Citizens' Council: Organized Resistance to the Second Reconstruction, 1954–64* (Champaign: University of Illinois Press, 1971). On Eastland, see Chris Myers Asch, *The Senator and the Sharecropper: The Freedom Struggles of James O. Eastland and Fannie Lou Hamer* (New York: New Press, 2008). See also Hodding Carter Jr., *The South Strikes Back* (Garden City: Doubleday, 1959).

27. Interview with Florence Mars, January 5, 1978, Center for Oral History and Cultural Heritage, University of Southern Mississippi, p. 16. On the murders of Lee, Smith, and others, see Payne, *I've Got the Light of Freedom,* pp. 29–44 ff.

28. *The Bell Returns to Mt. Zion,* p. 48. For draft versions of the *Life* entry, see Florence Mars Papers, Mississippi State University Archives, box 2.

29. Florence Mars Papers, Mississippi State University Archives, box 2.

30. Ibid.

31. Florence Mars, "The Fair: A Personal History," unpublished typescript, copy in Neshoba County Library.

32. *Witness in Philadelphia,* p. 31; *The Bell Returns to Mt. Zion,* pp. 48–49.

33. See Devery S. Anderson, *Emmett Till: The Murder that Shocked the World and Propelled the Civil Rights Movement* (Jackson: University Press of Mississippi, 2015). See also Mamie Till-Mobley and Christopher Benson, *Death of Innocence: The Story of the Hate Crime that Changed America* (New York: Ballantine, 2004), and Harriet Pollack and Christopher Metress, eds., *Emmett Till in Literary Memory and Imagination* (Baton Rouge: Louisiana State University Press, 2008).

34. Thomason, *Delta Rainbow,* p. 11.

35. Bryant, quoted in William Bradford Huie, "The Shocking Story of Approved Killing in Mississippi," *Look Magazine,* January 1956. See also Huie, "What's Happened to the Emmett Till Killers?" *Look Magazine,* January 1957. The closing arguments of the defense, widely reported in the press, are included in Mamie Till-Mobley and David Barr III, *The Face of Emmett Till* (Woodstock, IL: Dramatic, 2006), p. 82.

36. *Witness in Philadelphia,* p. 75. On the Meredith riot, see William Doyle, *An American Insurrection: James Meredith and the Battle of Oxford, Mississippi, 1962* (New York: Doubleday, 2001), and Charles W. Eagles, *The Price of Defiance: James Meredith and the Integration of Ole Miss* (Chapel Hill: University of North Carolina Press, 2009).

37. Copy of letter from Florence Mars to Gail Falk, July 23 (1968?), Florence Mars Papers, Mississippi State University Archives, box 1; interview with Betty Bobo Pearson by James Campbell, August 26, 2015.

38. *Neshoba Democrat,* April 9, 1964. For Rainey's campaign speech, see *Witness in Philadelphia,* p. 76.

39. Interview with Betty Bobo Pearson by James Campbell, August 26, 2015; interview with Florence Mars by James Campbell, July 26, 2003; and *Witness in Philadelphia,* pp. 84–119 ff. For further information on the conflict in the church, see interview with Clay Lee, minister of Philadelphia's First Methodist Church, July 8, 23, 1980, Center for Oral History and Cultural Heritage, University of Southern Mississippi, and interview with Clay Lee by James Campbell, June 19, 2013.

40. Mars's journals and notes from the period, including references to her reading, are included among her papers at the Mississippi Department of Archives and History, box 1.

41. Interview with Lynn Eden by James Campbell and Robbie Zimbroff, December 12, 2011. See also Florence Mars, *The Lake Place Burnside Family Story* (n.p., 1995), and Mars, *The Bell Returns to Mt. Zion* (Philadelphia, MS: Stribling, 1996).

42. *The Bell Returns to Mt. Zion,* p. 19.

43. Falk recounts the visit in her blog, "Freedom Song," available at https://freedomsongs11.wordpress.com/2012/01/31/florence-mars-witness-in-philadelphia/.

44. Notes from and reflections on her conversations with Collier, Jones, and the Coles are scattered throughout box 1 of Mars's papers at the Mississippi Department of Archives and History. See also interviews with Clinton Collier, July 28, 1981, and June 25, 1994, Center for Oral History and Cultural Heritage University of Southern Mississippi, and interview with Lillie Jones, December 11, 1974, Center for Oral History and Cultural Heritage, University of Southern Mississippi. She was "an angel," Collier said of Mars after her death. "That little woman stood up when whites folks would not have dared to come out to my house." Quoted in Dearman, "Florence Mars," pp. 46–47.

45. Interviews with Dick Molpus by James Campbell, July 17, 2003, September 9, 2012, and June 19, 2013; interview with Betty Bobo Pearson by James Campbell, February 25, 2018. The confrontation at the courthouse is described in Adam Goudsouzian, *Down to the Crossroads: Civil Rights, Black Power, and the Meredith March against Fear* (New York: Farrar, Straus and Giroux, 2014), pp. 171–78, and Taylor Branch, *At Canaan's Edge: America in the King Years, 1965–1968* (New York: Simon and Schuster, 2006), pp. 487–89.

46. For the text of Molpus's and other speeches at the twenty-fifth anniversary commemoration, see *Neshoba Democrat,* July 5, 1989. See also Philadelphia Coalition, "Statement Asking for Justice in the June 21, 1964, Murders of James Chaney, Andrew Goodman and Michael Schwerner," *Neshoba Democrat,* June 24, 2004.

LIST OF PHOTOGRAPHS

All images in the main body of the book come from the Florence Mars Collection at the Mississippi Department of Archives and History (PI/Z/1770/ Series II) and are used by permission. Mars took most with a Graflex 22, although some of the later photographs were made with a Leica IIIf that she acquired in the late 1950s or early 1960s. The images were scanned from original negatives in TIF format at a resolution of 1200 DPI.

Mars printed and reprinted many of the photographs in her home darkroom, providing insight into how she wished particular images to be seen. Where we have such evidence, we have tried to honor her intentions. Most of the photos, however, appear as she originally shot them, without cropping or reframing. A few images have received minor retouching to repair scratches or other damage.

Establishing the particulars of images—precise locations, dates, and the identity of people within them—is extremely difficult. Mars penciled captions on the back of a few prints, and we have gleaned information about other photos from her journals and personal papers. Interviews with surviving friends, family members, and long-time residents of Neshoba County have enabled us to attach names to a few other faces. In the end, however, specific information about many of the photographs remains elusive. The name of the woman who graces the book's cover, for example, remains unknown to us, although we think we know the occasion—a picnic following Sunday service at the Sipsey Church in southern Neshoba County, probably in 1956.

The brief captions that follow represent our best effort to establish the dates and settings of different photographs, as well as the names of individuals within them. We offer them with sincere apologies for all errors and omissions.